LEGENDARY L

OF

HARRISBURG

PENNSYLVANIA

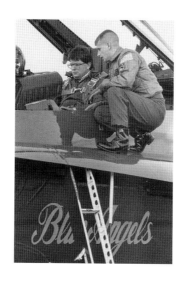

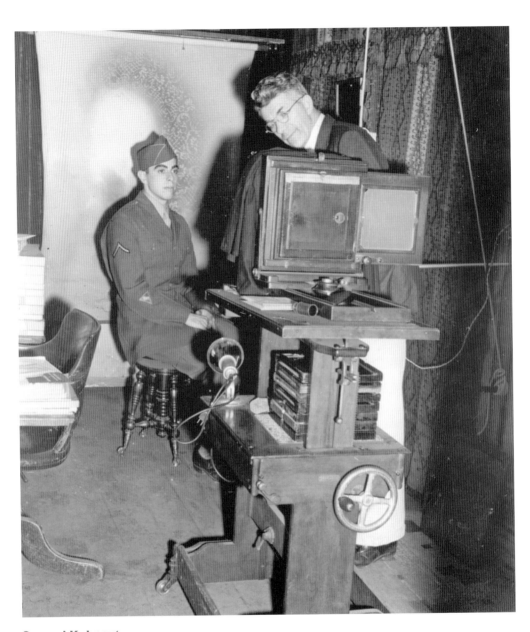

Samuel Kuhnert

This image shows Samuel W. Kuhnert taking a portrait of an Army soldier on October 16, 1943, at his Harrisburg studio at 1011 North Third Street. Kuhnert was popularly known for taking aerial photographs of Pennsylvania while strapped on the wings of World War I biplanes. He also captured images of accidents, funerals, and crimes. (Courtesy of Dauphin County Historical Society.)

Page 1: Rod Frisco

Harrisburg *Patriot-News* sports reporter Rod Frisco is shown in the cockpit at the 1988 Harrisburg International Airport air show. (Courtesy of Rod Frisco.)

LEGENDARY LOCALS

OF

HARRISBURG
PENNSYLVANIA

TODD M. MEALY

For all general information, please contact Arcadia Publishing:
Telephone 843-853-2070
Fax 843-853-0044
E-mail sales@arcadiapublishing.com
For customer service and orders:
Toll-Free 1-888-313-2665

Visit us on the Internet at www.arcadiapublishing.com

Dedication
This book is dedicated to my wife, Melissa, whose love is legendary.

On the Cover: Clockwise from top left:
Jeanine Turgeon, judge (Courtesy of Dauphin County Historical Society; see page 98), Graham Hetrick, Dauphin County coroner (Author's collection; see page 106), Harry Chapman III with his son Four Chapman, coach (Courtesy of Four Chapman; see page 44), Lavinia Lloyd Dock, suffragist (Courtesy of National Library of Medicine; see page 16), Kirk Smallwood, high school basketball coach (courtesy of Dauphin County Historical Society; see page 55), Jeremy Linn, Olympic swimmer (Courtesy of Dauphin County Historical Society; see page 68), Peter Wambach, radio show host (Courtesy of Joe Wambach; see page 36), Stephen R. Reed, mayor (Courtesy of Dauphin County Historical Society; see page 93), J. Horace McFarland, city reformer (Courtesy of Dauphin County Historical Society; see page 92).

On the Back Cover: From left to right:
Anne Durr Lyon, educator and humanist (Courtesy of Dauphin County Historical Society; see page 118), Ricky Watters, professional football player (Courtesy of Dauphin County Historical Society; see page 61).

CONTENTS

ACKNOWLEDGMENTS

There are so many people I need to thank in my life, specifically when it relates to their help with this book.

First and foremost, I have been extremely fortunate that I have received such kind and generous help from the team at Arcadia Publishing. Erin Vosgien and Kris McDonagh were valuable editors and advisors during the writing of this book. Of the many wonderful local historians in Harrisburg, Calobe Jackson Jr. is second to none. I also wish to thank David Puglia of Penn State-Harrisburg University, who recommended me for this project. Award-winning photojournalist Sean Simmers was a great help. Simmers selflessly allowed me the use of many of his remarkable photographs. I am grateful to the curator of the Dauphin County Historical Society Stephen Bachmann. Unless otherwise noted, all images appear courtesy of the Dauphin County Historical Society.

A special thank-you to my parents, Tom and Maurene, who moved my siblings and me to Harrisburg when I was five years old.

INTRODUCTION

Central Pennsylvania is a major urban area comprised of numerous cities, towns, and boroughs that stretch from the City of Lebanon in the east to Carlisle in the west, each with roughly 50,000 residents. More than half a million people live in the metropolitan area. In the center of this populace is Harrisburg, the commonwealth's capital city. In spite of its small population, Harrisburg has many of the country's most recognizable legends, from actors to athletes, politicians to humanists, and on-air personalities to war heroes. Many of Harrisburg's local legends can be seen on the big screen or read about in the textbooks of American history. Stories about Harrisburg's legends can be learned in various halls of fame across the country, including the National Football League, the National Basketball Association, the National Wrestling Association, and the Pennsylvania Broadcasters Association. It is a city that gives many people great pride. Several schools, scenic points, and apartment buildings have been named after Harrisburg's legends.

Harrisburg, situated on the eastern bank of the Susquehanna River, is positioned on a peninsula formed by the river on the west side, the Paxton Creek to the east, and to the south the land extends toward the junction of the creek and the river. Perhaps the most charming view of the city is the various islands that divide the water at points within the Susquehanna River. The Paxtang tribe first inhabited the area as early as 3,000 B.C. Around 1719, John Harris Sr. settled amongst the local population. He acquired 800 acres of land in the region and built a house along the Susquehanna River bank, where he became a fur trader. After his passing, his son John Harris Jr. and son-in-law William Maclay laid plans to create a town on his vast terrain, which was subsequently named Harrisburg. In 1791, Harrisburg was incorporated as a borough. In October 1812, it became Pennsylvania's capital city.

By 1850, Harrisburg had become a burgeoning capital with signature edifices, a large free African American population, and a myriad of religious denominations. Positioned at the city center was the state capitol building, a handsome looking structure situated in the most perfect location. The state house was known most for its imposing appearance. It sat on the most elevated part of the city facing

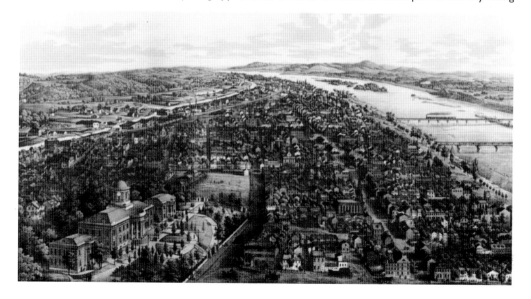

toward the Susquehanna River from which the ground gradually descended. Its center building was surmounted by a fine looking dome that visitors were permitted to ascend to the top and look out at a truly magnificent view of the city's brick houses, cottages, churches, studded water, and high mountains that casted its shadow over the Susquehanna glides. The south lawn of the state house, situated adjacent to Market Street, was a courtyard where city residents often larked about, relaxed, and hosted public rallies. Behind the capitol flowed the Pennsylvania canal. Visitors were often impressed by the appealing bridge that stretched overtop the inland waterway allowing farmers to enter from the countryside.

At the onset of the Civil War, Harrisburg's Camp Curtin had become the training center of the Union Army. Since the city sat at the apex of the state's railway network, Harrisburg was connected to Philadelphia on the east, Pittsburgh on the west, and to Hagerstown, Maryland, to the south. Every Union soldier had to come through Harrisburg. Consequently, Harrisburg always remained an important target for Gen. Robert E. Lee. First in 1862 and again in 1863, Gov. Andrew Curtain and local leaders mobilized many Harrisburgers to protect the city from an invasion by the Army of Northern Virginia.

Before, during, and after the Civil War, countless residents were committed to the cause of freedom. Because of its large African American population, city residents who had once harbored freedom seekers in their churches and homes were sequentially working for academic, political, legal, and economic equality.

At the turn of the century, Harrisburg was a sullied city. Brothels and gambling dens of East State Street had a notorious reputation across the state. Much of the city was besieged with poverty and ethnic rivalries. Capitol Park was considered one of the prettiest boulevards in Pennsylvania, but city streets were not yet paved. Areas along Front Street were littered with trash. Polluted pockets were featured along the riverbank. Then stepped in Mira Lloyd Dock, who in 1896 launched the "City Beautiful" movement. By 1900, Vance McCormick, J. Horace McFarland, and many of the city's major players were on board her initiative to install a safe water supply, sewage, parks, extensive street paving, and more.

During much of the 20th century, the mood in Harrisburg had always remained positive in spite of two world wars, the Great Depression, and racial turmoil. Local sports have a lot to do with that, particularly the success of the city's prevailing football teams. Harrisburg Tech dominated the gridiron until the 1930s. By 1960, the John Harris Pioneers had established dominance in the sport. Local high schools Steelton Highspire and Bishop McDevitt soon rivaled the Pioneers, which in 1972 had merged with William Penn to become Harrisburg High School. Collectively today, the three schools are among Pennsylvania's most successful football programs. On the baseball diamond, the Harrisburg Giants of the Negro Baseball League featured several of country's greatest ball players, including Spottswood Poles, Oscar Charleston, and Herbert "Rap" Dixon. Now, the Harrisburg Senators are the featured baseball attraction. Harrisburg has also been fortunate to boast a number of basketball, swimming, soccer, track and field, and Olympic legends. The heritage of Harrisburg has also expanded nationally due to the number of legendary locals who made professional decisions that pushed them to Hollywood, Washington, DC, and a number of other influential cities across the country.

Lately, Harrisburg has had to deal with tough times related to a changing tax base, government inconsistency, violent crime, flooding, academic oversight, and urban redevelopment. Yet its local legends have helped steer the city through choppy waters. This book is about 150 people who have contributed to the founding and subsequent reinvention of the city. We acknowledge that these legends, while some private citizens and others public servants, are individuals devoted to their families, who have overcome personal hardships, and endured the burdens of responsibilities not disclosed to the public. It is perhaps a perfect juxtaposition, as the legendary locals mentioned herein have much to do with the development of Harrisburg, Pennsylvania.

CHAPTER ONE

Pioneers, Trailblazers, and Titans

Today, a hollow grave surrounded by an iron fence along South Front Street marks the resting place of John Harris Sr., a man who arrived in the wilderness along the Susquehanna River around 1719 with hopes of bridging the relationship between local Indians and the William Penn family. Harris built a house along the river where he created a trading post and ferry service to help travelers during high water levels. Upon his death in 1748, his son, John Harris Jr. assumed control of the family estate. To avoid periodic flooding, John Harris Jr. erected a mansion higher on the riverbank. He also worked with his brother-in-law and surveyor William Maclay to get Harrisburg incorporated as a borough in 1791. In October 1812, Harrisburg was named Pennsylvania's capital city. Since then, the burgeoning city became home for many of the country's political and social difference-makers. In the 19th century, the influence of civil rights icon William Howard Day, Civil War hero Ephraim Slaughter, and secretary of war and minister to Russia Simon Cameron sculpted the city. The 20th century featured political minds like Vance McCormick, Genevieve Blatt, and George Gekas. Not many know that the former Speaker of the House Newt Gingrich was born in Harrisburg. The first director of homeland security and governor Tom Ridge lived in the city for many years.

John Harris Sr.
The first European settler to this area was John Harris Sr. (1673–1748). About 1719, Harris, a licensed trader, settled along the riverbanks of what was to become Harrisburg. In 1733, Harris constructed a ferry across the Susquehanna River known as "Harris's Ferry." He had acquired 800 acres of land around his ferry. When he died in 1748, his son John Harris Jr. took over management of the family estate, including the trading business and ferry. Harris Jr. made plans to construct a town on his father's vast land. So in 1791, Harrisburg was incorporated as a borough. In 1812, it became the state capital. There are no pictures of John Harris Sr. or John Harris Jr., but here is a photograph of Secretary of War Simon Cameron sitting outside the Cameron-Harris Mansion on South Front Street.

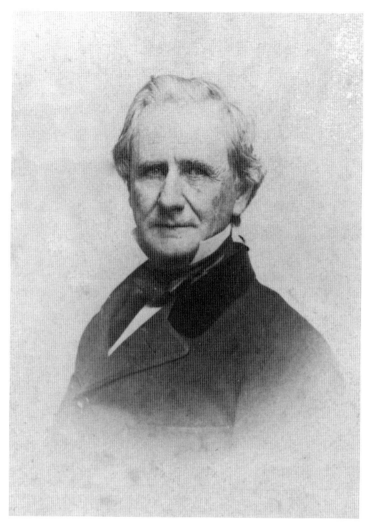

Simon Cameron

Orphaned at age nine, Simon Cameron, born March 8, 1799, grew to become a renowned politician who made his home in many places. By way of Lancaster County and Washington, DC, Cameron arrived in Harrisburg in 1824. Throughout his career, Cameron was a newspaper publisher and a key player in the construction of the Pennsylvania Canal and several railroads that all ran through Harrisburg. In 1844, Cameron was elected to fill the United States Senate seat once occupied by James Buchanan, who had recently resigned to serve as Pres. James Polk's secretary of state. Cameron served in the Senate from 1844 to 1849, and again from 1856 to 1861. His influence in Pennsylvania helped sway the Republican vote toward Abraham Lincoln in the 1860 presidential election. In return, Lincoln appointed Cameron secretary of war and later ambassador extraordinaire to the Russian Empire. Cameron moved into the John Harris Mansion on South Front Street in 1863. It was from the doorstep of this house that Cameron received soldiers of the United States Colored Troops during the nation's only Grand Review of Black Civil War soldiers. For years in Harrisburg, Cameron controlled the Republican political machine. In 1866, Cameron was again elected to the Senate. He resigned in 1877 so that his son James Donald Cameron could occupy his seat. Cameron left his mansion in Harrisburg in 1889 to live out the remainder of his life in the place where he was born, Maytown, Pennsylvania. He died that year on June 26, 1889.

William Howard Day

When it comes to pulling heroes out of the shadows, no one is more unheralded than William Howard Day (1825–1900). Day was the valedictorian of his class and the third African American to graduate from Oberlin College (1843–1847). He acquired a master's degree from Oberlin in 1855 and a divinity doctorate from Livingstone College in 1888. Day was a leading abolitionist before the Civil War. He was the president of the Ohio Anti-Slavery Society, chairman of Underground Railroad operations in Cleveland and Chatham, Ontario, and teacher at the Buxton Refugee Slave Mission. In 1858, John Brown met with Day in Chatham. At the meeting, Brown paid Day to print his provisional constitution. When he was done, Day hid several copies in flour barrels and sent them to Brown's men before their ill-fated Harper's Ferry raid. Day's first visit to Harrisburg occurred 1865 when he addressed returning USCT soldiers. He settled permanently in Harrisburg when he accepted a clerkship for auditor general Harrison Allen in 1871, making him the first African American hired for a state position. During his 29 years in Harrisburg, Day published the *Our National Progress,* was a five term general secretary for the AME Zion Church, and was an orator for the Odd Fellows and Republican Party. Day hosted Ulysses Grant during a visit in 1879 and was received by presidents Grover Cleveland (1885) and Benjamin Harrison (1889, 1891) at the White House. Day is known most for his six terms on the Harrisburg school board. He was elected to serve as its president in 1891 and 1892, respectively, making him the first African American school board president in the United States. As a board member and president, Day oversaw gender and racial integration at Harrisburg High School. In 1893, Day was elected president of the Dauphin County School Directors' Association and in 1896 was elected to the Pennsylvania State School Directors' Association. Day is buried at Lincoln Cemetery. Today, a housing development in Harrisburg and a cemetery in Steelton are named after him.

Andrew Curtain

Born in Bellefonte, Andrew Curtain (1817–1894) came from a family involved in both politics and war. His preparatory education was received at Harrisburg and Milton Academies, and later from Dickinson College. His service as Pennsylvania's governor from 1861 to 1867 was Curtain's crowning contribution. As governor during the Civil War, he supervised the development of the first and largest Union camp (present-day Farm Show) in Harrisburg.

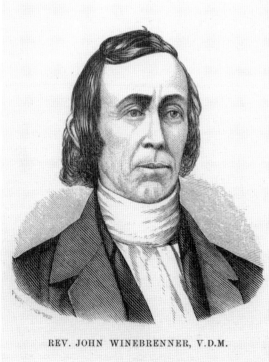

REV. JOHN WINEBRENNER, V.D.M.

Rev. John Winebrenner

John Winebrenner (1797–1860) arrived in Harrisburg about 1820. In 1830, he founded the Church of God. His congregation was made up of evangelicals who were involved in the antislavery movement. Winebrenner was a founding member of the Harrisburg Anti-Slavery Society in 1836. He died at his Harrisburg home in September 1860.

Olin Harris

Harrisburg's *Music Til Midnight* WHP radio broadcaster is remembered as a minister and gospel musician with optimism that earned him the respect of everyone he encountered. His broadcasting career began in 1957 as the founder and executive producer of *Echoes of Glory* on WKBO 1230 AM. Within a decade, Harris (1934–2009) was hosting his own show on WHP Radio and Television. It was a job that made him one of America's first full-time African American broadcasters with the CBS affiliate. Before his death in 2009, he was honored with a Lifetime Achievement Award from the Pennsylvania Association of Broadcasters, was named NAACP Man of the Year, and inducted into the Pennsylvania Association of Broadcasters Hall of Fame. The image below shows Harris with hosts of the Schindler's United Fund in 1974. (Courtesy of Kirsten Harris.)

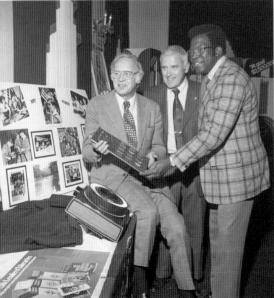

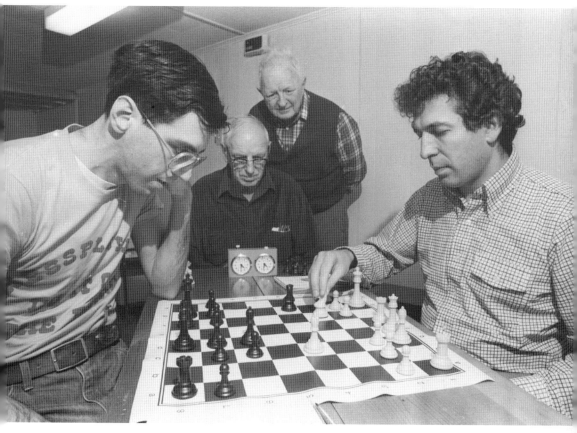

Ralph Kinter

After many fledging years, members of the Appalachian Audubon Society elected Ralph Kinter to become their president in 1984. As president, Kinter (1915–2002) wrote news columns titled "From the President's Perch" and "In the Field with . . . Ralph H. Kinter," crafted slide show presentations for senior citizens, and created Audubon Adventure Clubs at area schools, which educated children by hosting film festivals and presentations. As president, he created a task force that studied plants and soil in Central Pennsylvania's wetlands called Wetland's Watch. For his leadership in the Wetland's Watch program, Kinter was awarded the Earth's Defenders Award by the National Audubon Society in 1992. He was also awarded Conservationist of the Year by the Pennsylvania Audubon Council. Apart from his role as the president of the AAS, Kinter was instrumental in forming Susquehanna Appalachian Trail Club, the Keystone Trails Association, the Stoney Creek Coalition, and the Governor Pinchot group of the Sierra Club. Kinter's interest in conservationism began in 1944 while he was a sergeant stationed on Attu Island where he took an interest in preserving rare plants that were being destroyed by military projects. He is pictured (standing) looking over the shoulder of friends playing chess.

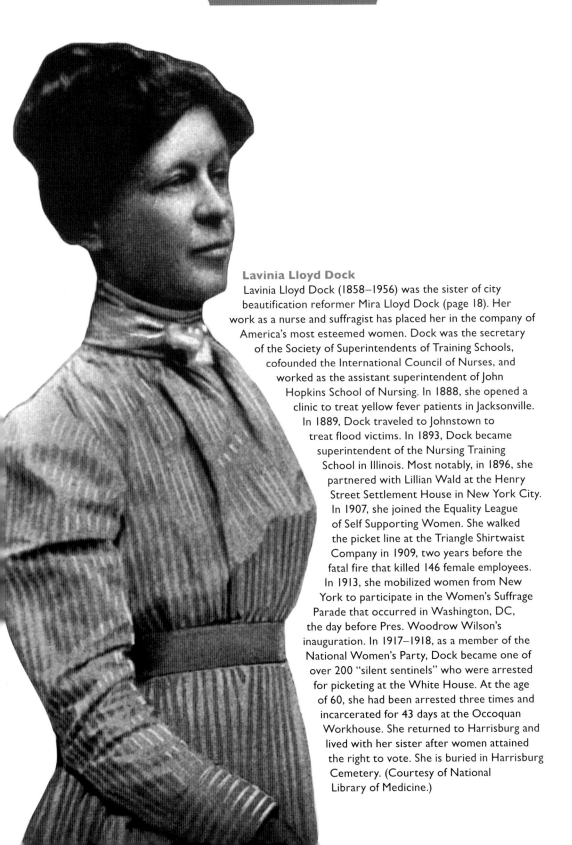

Lavinia Lloyd Dock

Lavinia Lloyd Dock (1858–1956) was the sister of city beautification reformer Mira Lloyd Dock (page 18). Her work as a nurse and suffragist has placed her in the company of America's most esteemed women. Dock was the secretary of the Society of Superintendents of Training Schools, cofounded the International Council of Nurses, and worked as the assistant superintendent of John Hopkins School of Nursing. In 1888, she opened a clinic to treat yellow fever patients in Jacksonville. In 1889, Dock traveled to Johnstown to treat flood victims. In 1893, Dock became superintendent of the Nursing Training School in Illinois. Most notably, in 1896, she partnered with Lillian Wald at the Henry Street Settlement House in New York City. In 1907, she joined the Equality League of Self Supporting Women. She walked the picket line at the Triangle Shirtwaist Company in 1909, two years before the fatal fire that killed 146 female employees. In 1913, she mobilized women from New York to participate in the Women's Suffrage Parade that occurred in Washington, DC, the day before Pres. Woodrow Wilson's inauguration. In 1917–1918, as a member of the National Women's Party, Dock became one of over 200 "silent sentinels" who were arrested for picketing at the White House. At the age of 60, she had been arrested three times and incarcerated for 43 days at the Occoquan Workhouse. She returned to Harrisburg and lived with her sister after women attained the right to vote. She is buried in Harrisburg Cemetery. (Courtesy of National Library of Medicine.)

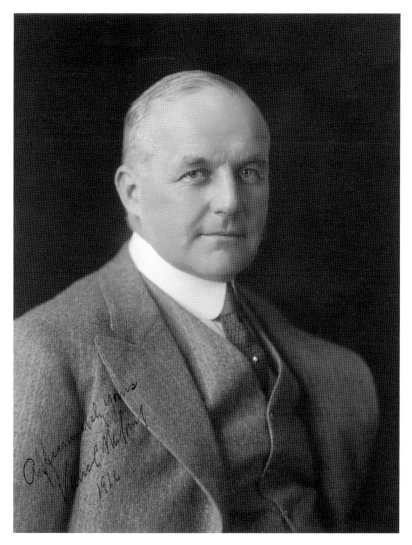

Vance McCormick

Born June 19, 1872, in Harrisburg, Vance McCormick was president of the Patriot Company, which published the *Patriot-News* and, in 1917, the *Evening News*. He became a trustee of Harrisburg Academy, Penn State, Yale, and the Pine Street Presbyterian Church. He also bought farms in Cumberland County, a pursuit that made him a leader in a statewide effort to improve agricultural methods and in the breeds of livestock raised by Pennsylvania farmers. For decades, McCormick spearheaded every major project in Harrisburg. Between 1900 and 1902, he was a member of the city council, leading the municipal reform movement. In 1900, he became the director of the Dauphin Deposit Trust Company. In 1902, McCormick was voted mayor of Harrisburg. In just one term as mayor, he is credited with supervising the expenditures of the first city beautification loan of $190 million which resulted in Harrisburg's facelift, including paved streets, a park system, modern sewers, and filtered water. Under his administration, gambling houses and other forces of vice disappeared as McCormick led the reformation of the city police and fire departments. In 1912, he was the manager for Woodrow Wilson's presidential campaign. Later, President Wilson hired him to serve as chairman of the War Trade Board during the Great War. Notwithstanding his prominent status throughout the country, McCormick spent his entire career in Harrisburg. He died June 16, 1946, and is buried in Harrisburg Cemetery.

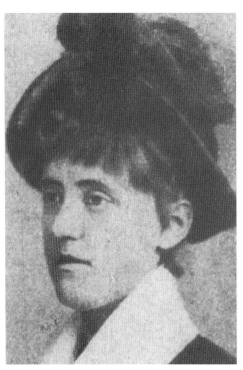

Mira Lloyd Dock

Mira Lloyd Dock was instrumental in launching the campaign to beautify Harrisburg, a city overwhelmed by sewage contamination, filthy water, and an excess of uninhabitable areas. Dock lived at 1427 North Front Street, residing next door to Vance McCormick. On December 20, 1900, Dock presented the Board of Trade with a plan that ultimately laid out the blueprint for "City Beautiful."

Maris Harvey Taylor

M. Harvey Taylor (1876–1982) was a city councilman, superintendant of parks and public property, and helped in the creation of the Sunken Gardens within Riverfront Park. He served as state senator from 1941 to 1964. Taylor was known nationally for leading the Republican machine in Pennsylvania from the 1930s throughout the 1960s. The image shows Taylor (seated) on his 102nd birthday.

Gov. John W. Geary
A hero of the Mexican and Civil Wars, perhaps the best example of Geary's leadership was as governor of Pennsylvania. It is a mark of his compassion that he reached out to the downtrodden and oppressed. For two terms, from 1867 to 1873, Geary developed a reputation for advocating suffrage for African Americans and occupational and educational equality for both races.

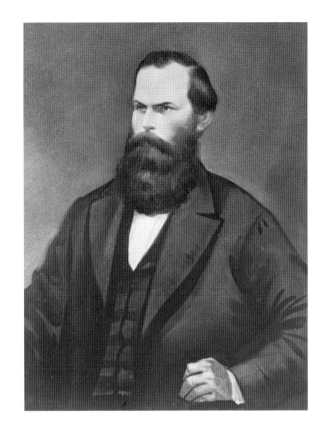

James Donald Cameron
The first-born son of Republican Party boss Simon Cameron and Margaret Brua, J. Donald Cameron (1833–1918) was the 32nd United States secretary of war. In 1876, Pres. Ulysses S. Grant appointed him secretary of war, a position his father once held. He also occupied his father's United States Senate seat in 1877. Cameron served in Congress for 20 years.

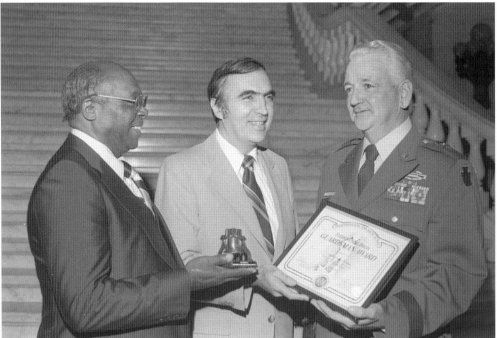

George W. Gekas

Pictured here (middle) receiving three National Guard Awards in 1978, United States Congressman George Gekas served the public for over 40 years. A 1948 graduate of William Penn High School, Gekas was an assistant district attorney for Dauphin County, member of the Pennsylvania House of Representatives, and a state senator. For many decades, Congressman Gekas played the piano at Bethesda Mission's annual Thanksgiving and Christmas dinners.

Thomas Morris Chester

Chester was a Harrisburg-born journalist and USCT recruiter. In 1863, he was conferred a captain of a regiment of black soldiers assigned to defend Harrisburg during the Gettysburg campaign. During the final year of the Civil War, he worked as a correspondent for the *Philadelphia Press*, making him the only African American to travel with the Army of the Potomac. (Courtesy of Cheyney University.)

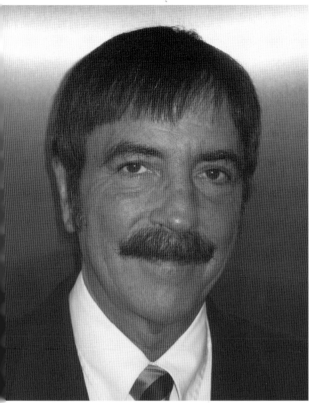

Jeb Stuart

There have been many renowned families that have lived along Front Street during the history of Harrisburg. Harris, Kelker, Rutherford, McCormick, and Boas are just a few of them. Today, it would be remiss of anyone to overlook the name Stuart. A resident of metro Harrisburg all of his life, Jeb Stuart is a "Front Streeter" that literally has his hands involved in Harrisburg's modern development. Having witnessed the "City Beautiful" movement earlier in the 20th century, his family built on Front Street three generations ago at a time when two-lane traffic flowed on the road. Stuart was a real estate developer responsible for cocreating the Simon Cameron School apartments and Emerald Point townhouses. He also worked as a co-leasing retail agent at Strawberry Square. The image shows a car on River Road in 1912. (Courtesy of Jeb Stuart.)

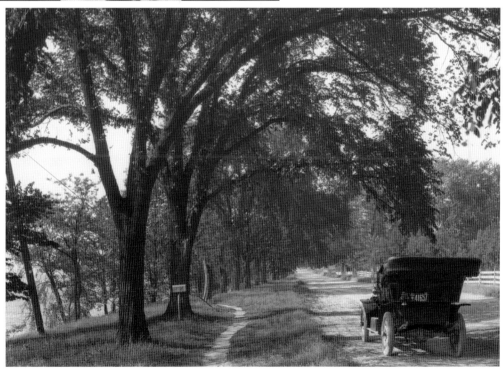

Genevieve Blatt

According to a 2012 CNN poll, more than three million women play high school sports. In 1972, however, the year that Title IX was passed banning gender discrimination in schools, fewer than five percent, or 30,000 teenage girls participated in sports. Two years after Title IX was invoked, Judge Genevieve Blatt (1913–1996) wrote the majority opinion concreting the law into American society. The ruling was groundbreaking and seemingly put a stamp on her already illustrious career. Blatt is remembered as the "First Lady of Pennsylvania Politics" because she spent 40 years with the Pennsylvania Democratic Party. From 1932 to 1972, she attended every Democratic National Convention as a presidential elector. In 1972, Blatt was elected to serve on the Pennsylvania Appellate Court. The victory made her the first woman elected to a statewide office. According to one Harrisburg historian, by the end of her career, Blatt received more votes than any person in Pennsylvania's history—including Simon Cameron and Gifford Pinchot. She was a candidate 17 times, winning 11 out of 14 statewide elections and two out of three local campaigns. Blatt was sworn into five different elected offices, six times in appointed ones, and 12 times to sit on temporary commissions. She devoted much of her spare time serving the needs of the Catholic Church, earning her three papal honors, including the Lady Grand Cross in the Equestrian Order of the Holy Sepulcher of Jerusalem.

C. Delores Tucker

C. Delores Tucker (1927–2005) is known best as the woman who was verbally attacked by controversial rapper Tupac Shakur. She was an outspoken critic of gangster rap and faced a storm of criticism from rappers because of her position. She was much more than an opponent of offensive rap lyrics. Tucker was born Cynthia Delores Nottage in Philadelphia on October 4, 1927, the 10th of 11 children. She played the organ and saxophone and directed the choir at her father's church. Before marrying William Tucker in 1951, she attended Temple University, Penn State University, and the University of Pennsylvania. According to her obituary in the *Washington Post*, Tucker was "an elegant woman who spoke with a stirring cadence [and] had a long history in the civil rights movement and politics." She raised money for the National Association for the Advancement of Colored People and marched with Martin Luther King Jr. on several occasions. In 1971, she moved to Harrisburg after she was appointed Pennsylvania's secretary of state by then-governor Milton Shapp. The job made her the highest-ranking African American woman in Pennsylvania's history. She held the position for six years. In 1977, Governor Shapp fired Tucker for using state employees to write policy speeches for which she was paid. Tucker failed in bids for lieutenant governor in 1978, the United States Senate in 1980, and for the House in 1992. She persisted in spite of the defeats. For 11 years, she served as chairwoman of the Black Caucus of the Democratic National Committee and was the founding member of the National Women's Political Caucus. She died October 12, 2005, of a heart ailment and lung condition. In April 2006, a state historical marker honoring Tucker was dedicated in front of the North Building in Harrisburg.

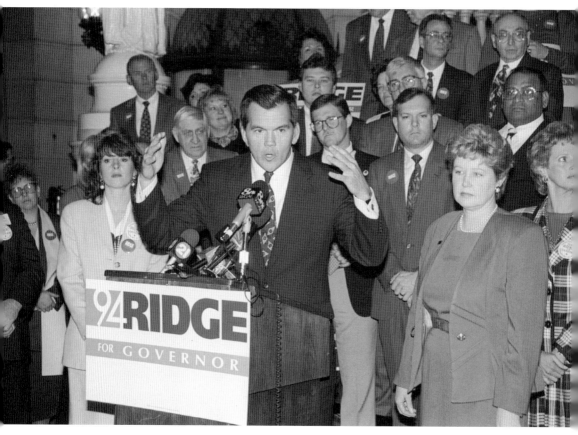

Tom Ridge

Tom Ridge, pictured in 1994 announcing his candidacy for governor, served as Pennsylvania's chief executive from 1995 to 2001. Ridge's second term was cut short in October 2001 when Pres. George W. Bush created the Office of Homeland Security and named him its first director. Ridge held the position until 2004. As the head of the United States' largest government agency since World War II, Ridge was successful in plugging holes in areas like aviation security and biodefense. His color-coded terror alert system is his signature counterterrorism program. A Vietnam War veteran, recipient of the Bronze Star for Valor, the Combat Infantry Badge, and the Vietnamese Cross of Gallantry, Ridge also served five terms in the United States House of Representatives.

CHAPTER TWO

Actors, Producers, and On-Air Personalities

Harrisburg has always been a city with rival newspapers. During the 18th century, the *Oracle* provided Harrisburgers with news, weather, and entertainment. In the 19th century, however, several newspapers emerged, namely the *Patriot-News* and the *Telegraph*. Radio and television stations have become the source of information in the 20th century. Radio stations WITF-FM, WKBO, WINK, WHPAM and television channels WTPA-TV, WCMB-TV, and WHBG-TV have featured many distinguished media personalities.

As the host of *Music Til Midnight* and *Echoes of Glory* for more than 50 years, Olin Harris was one of Harrisburg's earliest radio personalities. Peter Wambach was arguably the most popular voice on radio. He became famous early in his career as host of *Harrisburg After Dark*. He also hosted *The Pete Wambach Show* and *Beat Pete*. Wambach's most popular show *This is Pennsylvania* aired across the state.

Three of Harrisburg's most successful Hollywood professionals are Carmen Finestra, Gerry Abrams, and Bobby Troup. Finestra is an award-winning producer of *The Cosby Show* and *Home Improvement*. Abrams produced *Black and Blue*, *Jekyll and Hyde*, and *44 Minutes: The North Hollywood Shoot-Out*. Troup was an actor and musician who wrote the legendary song "Route 66" and starred in television programs such as *M*A*S*H* and *Emergency!* Harrisburg natives Pauline Moore and Nancy Kulp are two beloved Hollywood actresses.

There have been award-winning anchors, Broadway actors, columnists, and models that have contributed to making Harrisburg one of a kind.

Carmen Finestra

Finestra was born in Harrisburg in 1947. After graduating from Bishop McDevitt High School, Finestra studied to be a priest for two years then attended Penn State University and graduated with a bachelor of arts in 1971. Finestra moved to New York and acted off-off-Broadway for three seasons with the Jean Cocteau Repertory Company where he performed in *Waiting for Godot*, *Tom Thumb*, and *A Midsummer's Night Dream*. A fellow actress told him about an opening as a gofer at the office of TV producer Joe Cates. Finestra got the job and caught Cates's eye because of funny memos he wrote. Cates gave Finestra his first writing job in 1976 on a Johnny Cash summer variety show. It was here that he met a young, still relatively unknown comedian named Steve Martin. Finestra later wrote material for Steve Martin's nightclub act, as well as television specials. Finestra is best known as the supervising producer for five-and-a-half seasons of *The Cosby Show*, and as the cocreator and executive producer of *Home Improvement*, starring Tim Allen. He also cocreated and executive produced *Thunder Alley*, starring Ed Asner, and *Soul Man*, starring Dan Aykroyd. In film, Finestra executive produced *Where the Heart Is*, starring Natalie Portman and Ashley Judd; and *What Women Want*, starring Mel Gibson and Helen Hunt. During his career, Finestra has won three Writers Guild of America Awards for his work on two Steve Martin specials and for *Time Warner Presents the Earth Day Special*. He was nominated for three Emmy Awards and a Humanitas Prize for *Cosby*, and in 1987 shared a Peabody Award with the other *Cosby* writers for outstanding achievement in television writing. Finestra has also been nominated for three Emmys and two Golden Globes for *Home Improvement*. He is pictured here in June 1987 at the Forum Building before giving the commencement address at his alma mater's graduation ceremony. In 1998, Finestra was named a Distinguished Alumnus of Penn State. His most recent honor came in 2010 when he was awarded the Gold Medal Award from the Pennsylvania Association of Broadcasters.

Robert Troup

Before staring in the television series *Emergency!* and the movie *M*A*S*H*, Bobby Troup got his kicks writing hit songs such as "Route 66." Troup wrote his signature song while he was traveling west along that historic roadway. Troup grew up in Harrisburg's Tenth Ward and attended city schools. In the 1930s, the Troup family owned the Troup Music House, School of Pianoforte on 15 South Market Street.

Ursula Abbott

In June 1993, Bishop McDevitt High School senior Ursula Abbott became Miss Pennsylvania Teen USA. Just weeks later, Abbott finished second runner-up in the Miss Teen USA Pageant. Her moment on television along side host Dick Clark made her one of the most talked-about teenagers in Harrisburg. Abbott has since appeared on *Guiding Light, Law and Order: Criminal Intent*, and the movie *Chapter 27*.

Ellen Brody Hughes

From 1990 to 2007, Hughes was the host of WITF-FM's *Desert Island Discs*, a radio show in which she interviewed over 800 local, regional, and nationally known musicians, artists, and politicians, asking them to imagine themselves as castaways marooned on a deserted island. Hughes asked her guests, "What would be the eight pieces of music you would need to survive?" (Photograph by Jeff Lynch, courtesy of Ellen Hughes.)

Chuck Rhodes

In 1973, WTPA-TV, present-day ABC27, hired Chuck Rhodes to work as an anchor at the station. Pictured here in 1987, Rhodes became a viewer favorite when he was reassigned to do weather forecasts. Consistency, insight, and humor led readers of *Harrisburg Magazine* to honor Rhodes as Top Television Personality and Favorite Weather Forecaster.

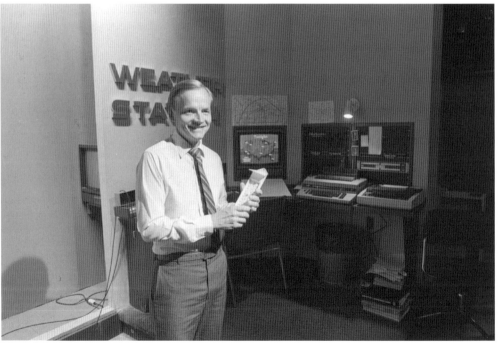

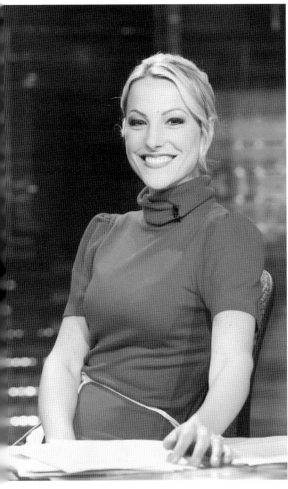

Lindsay Czarniak

Lindsay Czarniak is an anchor on ESPN's SportsCenter. Born in Harrisburg, her first job was as a production assistant with CNN. Her sports interview show on NBC4 in Washington, DC, called *Lunch with Lindsay*, attracted the attention of NBC, who hired her to report from the 2006 Winter Olympic Games in Turin, Italy, and the 2008 Summer Games in Beijing, China. Czarniak made her first broadcast at SportsCenter in August 2011 and has cohosted the six o'clock show since December 2012. She also is a pit reporter for TNT's NASCAR Sprint Cub Series and has replaced Brent Musburger as host of ABC's Indianapolis 500 *Greatest Spectacle in Racing*. (Courtesy of Joe Faraoni and ESPN Images.)

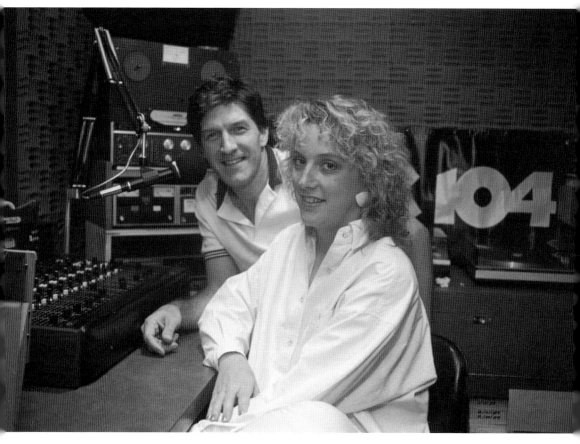

Sue Campbell and Tim Burns
Sue Campbell has been part of Harrisburg's most popular morning radio show for decades as a personality on WINK 104. In 1988, Campbell got her start on air after she impressed the morning show host, Tim Burns, with tongue-in-cheek hallway banter. Burns, a veteran of morning radio shows, arrived in Harrisburg in 1979. Campbell had always been from the city. She was hired at age 18 to be a receptionist at the station. When given the opportunity, Campbell made Burns's audience fall in loved her. Soon, the two became cohosts of *Tim and Sue, and the WINK Morning Zoo!* They are pictured here in June 1989.

Susannah McCorkle

Born on New Year's Day in 1946, the official first day of the baby boom, Susannah McCorkle (1946–2001) was one of the most famous international jazz singers in American history. Born in California, McCorkle's parents moved her to Bellevue Park in Harrisburg where she was an honors student and choir singer at John Harris High School. At age 55, she committed suicide by leaping from her New York City apartment.

Gerald W. Abrams

Gerry Abrams grew up on North Fifth Street while attending William Penn High School. He later graduated from Penn State University, where he became a Distinguished Alumnus in 1986. His Emmy award–winning career in television began in 1965. He has executive produced BBC's *Black and Blue*, *Nuremberg*, FX's *44 Minutes*, Showtime's *Out of the Ashes*, and ESPN's *Four Minutes*. (Courtesy of Gerry Abrams.)

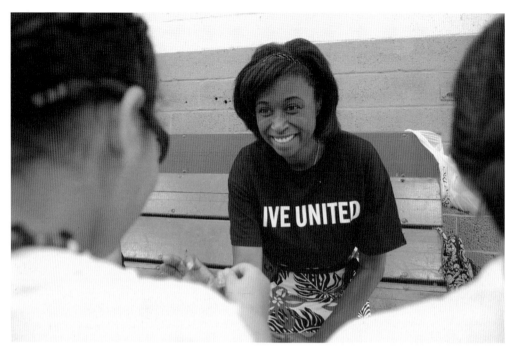

Valerie Pritchett

Known first and foremost as an anchor on ABC27 News, Valerie Pritchett runs an adoption project called Val's Kids, which helps children in foster care find adoptive homes. Living in Harrisburg helps her balance her job with ABC27 and the various community service work she commits herself to, including the Susquehanna Service Dogs, the Central Pennsylvania Food Bank, and the American Literacy Corporation. Pritchett is pictured above at an event hosted by United Way's Women Leadership Network. Below, she is shown with Floyd Stokes, founder and executive director of the American Literacy Corporation. (Courtesy of Valerie Pritchett.)

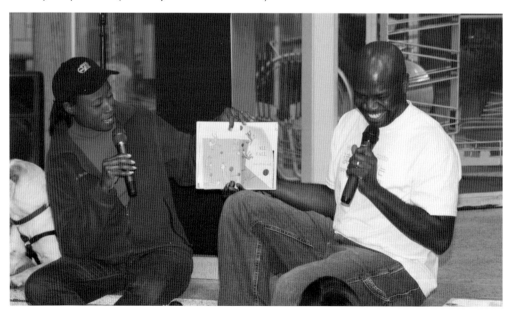

Jason Bristol

Since joining WHP-TV (CBS 21) in 2005, Jason Bristol has been a multiple Emmy Award recipient as the station's sports director. Bristol has won 12 Emmy Awards—for categories such as Most Outstanding Sports Anchor and Most Outstanding Sports Reporter—and has received 28 Emmy nominations. He was instrumental in helping WHP-TV win its first and only regional Edward R. Murrow Award for its continuing coverage in 2009 of the proposed National Sports Hall of Fame project. Bristol also has earned numerous awards from the Pennsylvania Associated Press Broadcasters Association for Enterprise Reporting, Continuing Coverage, News Feature Story, Sportscast, Sports Play-by-Play, and Best Sports Feature Story. (Courtesy of Jason Bristol.)

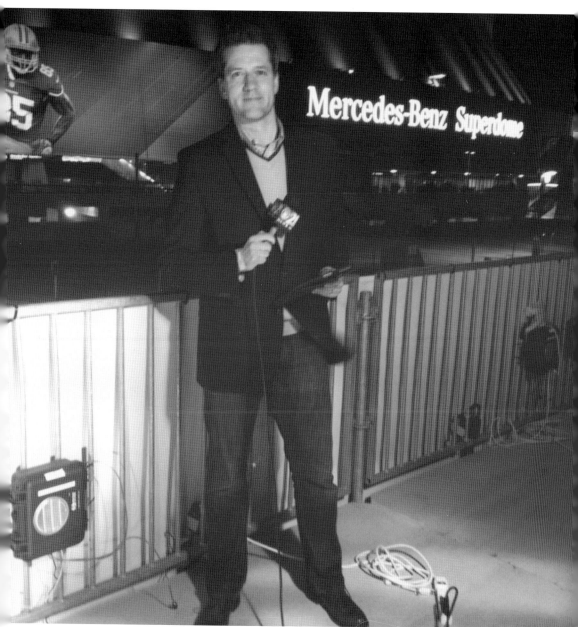

Nancy Kulp

Born in Harrisburg, the daughter of a lawyer and a schoolteacher, Nancy Kulp (1921–1991) is best known for her role as Jane Hathaway in the *Beverly Hillbillies*. She also appeared in 16 movies, among them *Sabrina* and *A Star Is Born*. Kulp encompassed a unique side of selflessness. During World War II, she volunteered as a member of the Women Accepted for Volunteer Emergency Service, or WAVES. Kulp, a Democrat, involved herself in politics in 1952 when she campaigned for Adlai Stevenson. In 1984, she ran unsuccessfully for the US House of Representatives from Pennsylvania's ninth district, representing Juniata County. After her campaign, Kulp worked as an artist-in-residence at Juniata College.

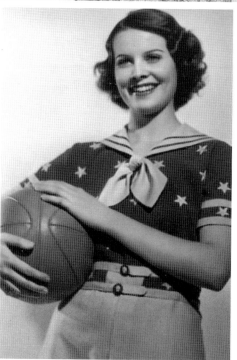

Pauline Moore

Pauline Moore (1914–2001) was a child when her father died serving in the Great War. She sold Liberty Bonds during the war by singing *Bring Back My Daddy to Me*. At 17, she signed her first contract with Universal Studios. Her first role was in the 1931 classic *Frankenstein*. During the 1930s, she appeared on the covers of *Ladies Home Journal*, *McCalls*, and *Cosmopolitan*. One portrait, "Hostess Girl," appeared on a 1934 Coca-Cola tray now considered a collector's item. In 1936, she was placed under contract with 20th Century Fox, playing in movies with Shirley Temple and Jane Withers. Moore's most famous role was as Mary Whittaker in the movie *Days of Jesse James*, starring opposite Roy Rogers. Second from the left, Moore, a graduate of William Penn High School, is shown at her 50-year class reunion.

Peter Cyrano Wambach

Born in Philadelphia, Pete Wambach (1916–2007) arrived in Harrisburg in 1939 at the age of 24. He quickly became a prominent citizen of Harrisburg who bore the catchy nickname "Mr. Pennsylvania" for his success as the radio show host of *This Is Pennsylvania*. Wambach was a balanced talent in the entertainment industry. He first worked for the AM radio station WKBO Fortress-1230. In 1953, he also opened a record distribution company on North Fourth Street called Wambach's Waxworks, Inc. In the 1950s, Wambach had two late night talk shows on WCMB-TV channel-27 called *Harrisburg After Dark* and *Beat Pete*. *Harrisburg After Dark* came on the air at 11:30 p.m. and was popular locally for preceding *The Tonight Show*. In *Beat Pete*, contestants asked questions that Wambach had to answer within three minutes. If he failed to provide correct answers, the show would donate to charity. In the 1960s, Wambach's popularity soared again because of his radio broadcast, the *Pete Wambach Show*. The show was mostly music, but on occasions Wambach had special guest appearances, including interviews with celebrities Muhammad Ali and Brenda Lee. From 1964 to 1985, Wambach hosted a five-minute radio show called *This is Pennsylvania*. The show was sponsored by the Pennsylvania Department of Commerce and later the Pennsylvania Rural Electric Corporation, and aired daily on more than 100 AM and FM radio stations in the state. With a signature opening, "Good day everyone. It's a beautiful day in Pennsylvania," Wambach's show informed listeners about a myriad of tidbits regarding Pennsylvania people, life, and culture. Wambach was major player in the state Democratic Party. He was a delegate at several Democratic National Conventions and served as press aide for Gov. George Leader and Lt. Gov. John Morgan Davis. Wambach was inducted into the Pennsylvania Broadcasters Hall of Fame in 1998. (Courtesy of Joe Wambach.)

CHAPTER THREE

Coaches, Sportswriters, and Athletes

Most would argue that athletes are the most popular legends that have come out of Harrisburg. Admittedly, it is an audacious assertion considering Harrisburg can claim national political leaders like Tom Ridge, Simon Cameron, and Newt Gingrich; Hollywood producers and actors like Carmen Finestra, Richard Sanders, Steve Pasquale, Pauline Moore, and Nancy Kulp; famous novelists John O'Hara and James Boyd; civic heroes like Thomas Morris Chester and William Howard Day; and scholars like professor Simon Bronner and Ann Durr Lyon. Notwithstanding the aforementioned legendary locals, Harrisburg's athletes, coaches, and sportswriters are the most memorable.

Of all the sports, football is king. Harrisburg Tech, who played their games on City Island during the first three decades of the 20th century, dominated the gridiron. After World War II, the John Harris Pioneers were virtually unbeatable. Coach George Chaump is the patriarch of a coaching tree that runs deep. Chaump's teams went 58-4 during his six seasons at John Harris. Mickey Minnich, who coached the Pioneers to the longest win streak in school history (38 consecutive wins), replaced Chaump. During the Chaump-Minnich era, several Division I athletes graduated from John Harris, including Jimmy Jones, Jan White, and Dennis Green. By the end of the century, football fans were fortunate to have watched Gary Ross, LeSean "Shady" McCoy, Ricky Watters, Danny Lansanah, Kenny Watson, Marques Colston, and many NFL players who received their start at high schools in Harrisburg.

Harrisburg can claim several Olympic athletes, including Dick Davies (basketball), Jeremy Linn (swimming), Hyleas Fountain (track and field), Henry Norwood "Barney" Ewell (track and field), and Ryan Whiting (track and field). Others made it professionally in their own unique way. Phil Davis is an Ultimate Fighting Champion; baseball player Al Chambers is Harrisburg's only No. 1 overall draft pick; and several basketball players bounced around the Continental Basketball Association (Julius McCoy), the National Basketball Association (Bob Davies), and the European Basketball League (Andy Panko).

Special Note: Although deserving, but not included in this chapter because they are from Cumberland County, are Jeff Lebo, Mickey Shuler, Billy Owens, Michael Owens, John Ritchie, Coy Wire, Kyle Brady, and Jim Thorpe.

George Chaump

When it comes to football coaches from Harrisburg, no name is more respected than George Chaump (1936–present). Born in Scranton, Chaump became familiar with Harrisburg when his high school coach became the boss at William Penn High School. Then, during his junior year at Bloomsburg University, Chaump suffered a serious knee injury and could no longer play football. In 1958, he was offered a job coaching at William Penn with his former high school coach. In 1962, Chaump accepted the head coaching position at John Harris High School. He remained at John Harris until 1967, earning a 58-4 record, including a stretch of 28 straight wins from 1965 to 1967. The John Harris Pioneers won the Central Penn League every season Chaump was their coach. In 1968, Woody Hayes hired Chaump to instruct the quarterbacks at Ohio State University. The Buckeyes defeated USC 27-15 in the Rose Bowl to win the national championship during his first season at OSU. He stayed at OSU 11 years. Chaump then accepted a job coaching running backs for the NFL's Tampa Bay Buccaneers. Three years later, he received his first head coaching position at the collegiate level at Indiana University of Pennsylvania in 1982. He earned a 24-16-1 record in four seasons at IUP before accepting the same position at Marshall University. Chaump was also at Marshall four seasons (1986–1990). In 1987, Chaump guided Marshall to the I-AA national championship game, losing by one point to Southeast Louisiana. In 1990, Chaump was named the head coach at the Naval Academy. He spent five years at Navy. Overall, Chaump compiled a 71-73-2 record in college. In 1997, he returned to the high school sidelines as the head coach at Central Dauphin High School. In his first season, Chaump led the Rams to a Quad-A District 3 championship. He acquired a 57-14 record during his six years at Central Dauphin. In 2003, he was inducted into the Pennsylvania Sports Hall of Fame. That same year, Chaump returned to coach Harrisburg High School, where he won three Commonwealth Division titles and one Quad-A District 3 championship.

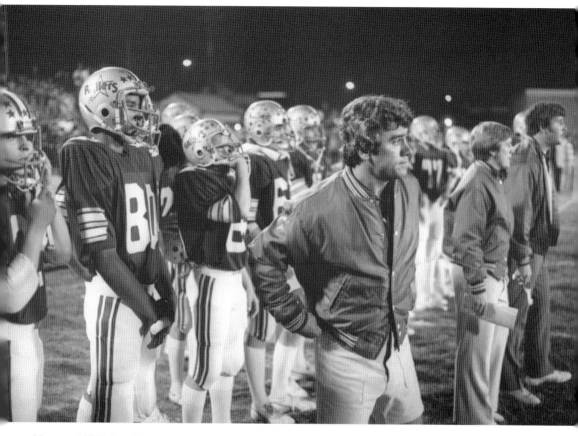

Howard "Mickey" Minnich

In less than a decade, Mickey Minnich is respected by gridiron fans as one of the top football coaches in the history of Pennsylvania. After graduating from William Penn High School and Gettysburg College, Minnich became an assistant coach on local legend George Chaump's John Harris Pioneers teams of the 1960s. After Chaump (page 38) accepted an assistant coaching position under Woody Hayes at Ohio State, Minnich became John Harris's boss. He was the head coach at John Harris from 1968 to 1970. In 1971, he was still the coach when John Harris and William Penn High Schools merged into Harrisburg High School. There was a time during his tenure at John Harris/Harrisburg when Minnich's teams won 39 straight games. After a short time away from the gridiron, Minnich accepted the head coaching position at Steelton-Highspire in 1977. He retired in 1980. He amassed a 76-8-3 record in eight years, including four Central Penn League championships and one South Penn League championship. In 1981, he assumed control of the Big 33 Football Classic, an annual high school all star football game that has been played at Hersheypark Stadium since 1958. Minnich had previously coached in the game three times, two years as head coach. As executive director of the Big 33 Classic, Minnich revitalized a faltering program at the time. He incorporated the special needs Buddy Program, and, among other things, the Academic Scholarship Program. Minnich also was the executive director of the Pennsylvania Scholastic Football Coaches Association from 1977 to 2006. He was inducted into the Pennsylvania Sports Hall of Fame in 1997. He currently is the director of Vickie's Angel Walk Foundation, a charity that provides support to cancer patients who cannot afford medical treatment. Minnich is pictured here November 10, 1978, on the sideline of Steelton-Highspire's game against Delone Catholic.

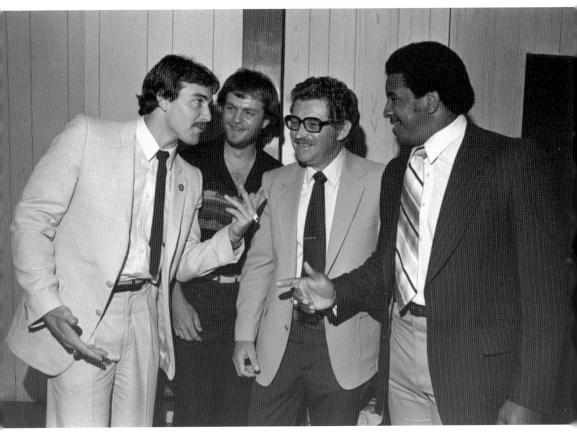

Dennis Green

Dennis Green is known in Harrisburg as the coach who has remained loyal despite many years spent out of the city, leading college and professional football teams. Born in Harrisburg on February 17, 1949, Green's childhood was one of personal hardship. When Dennis was 11 years old, his father, Penrose, died of a ruptured appendix. Two years later, his mother Anna passed away of cancer. He lived in the city with an older brother who was given permission to leave the US Air Force to care for Dennis. Green attended John Harris High School, was the 1966–1967 senior class president, and was recruited to play football by the Iowa Hawkeyes. He played tailback at Iowa while studying finance. After a brief stint in the Canadian Football League, Green was hired as an assistant coach at the University of Dayton in 1973. He returned to coach the running backs at Iowa from 1974 to 1976. Between 1977 and 1988, he was on the coaching staffs at Stanford and the San Francisco 49ers. It was with the 49ers that Green learned under legendary coach Bill Walsh. In 1981, Green received his first head-coaching position at Northwestern, where the Wildcats had lost 34 straight games. In his first season (1982), Northwestern went 3-8, but Green was named Big 10 Coach of the Year for the turnaround. Green became the head coach at Stanford in 1989. In 1992, Green became the second African American head football coach in the National Football League when he signed a contract with the Minnesota Vikings. He remained in Minnesota until 2001. Green has also coached the Arizona Cardinals (2004–2006) and is currently the head coach of the United Football League's Sacramento Mountain Lions. Green (far right) is shown in 1981 at the Post Office Sports Banquet with Scott Fitzkee and others.

Jan White

It would be difficult for anyone to argue against the assertion that the John Harris Pioneers football team dominated the sport in Central Pennsylvania during the 1960s. The Pioneers won 105 of 113 games between 1960 and 1970. John Harris won or shared the Central Penn League championship every season; nine times outright and shared the title with Steelton-Highspire in 1964. Good coaching had a lot to do with the program's success. Yet, so did the talent. Arguably, the program's all-time greatest athlete was wide receiver Jan White. White played for John Harris teams coached by local legend George Chaump (page 38). The Pioneers never lost a game while White was a member. After his senior year, he accepted a scholarship to play football for Woody Hayes at Ohio State University. His class is considered one of college football's all-time greatest. Forced by NCAA rules to play freshman football in 1967, his underclassman team went undefeated. In his sophomore year, White and the Buckeyes prevailed in every game and won the National Championship in 1968. During his junior year, the Buckeyes were 8-0 before they lost to their archrival—the University of Michigan. Apart from his Pennsylvania all-star team that lost to Texas in the Big 33 Classic, Ohio State's loss to Michigan was White's first in his football career, including his experience playing junior high, high school, and college football. Despite the loss, the Buckeyes finished that season 8-1 and won the Big Ten championship. White concluded his career at Ohio State with a 9-1 record and a second Big Ten title. In 1971, the Buffalo Bills drafted White, where he played two seasons in the National Football League. Football aside, White was a strong student at John Harris, graduating in the top 10 percent of his class. He was also a state champion track and field athlete, having won the PIAA Class-A title in the 220-yard dash with a time of 22 seconds flat; twice won the 120-yard-high hurdles in 1966 and 1967 with 14.6 seconds each year; and won the title in the 180-yard low hurdles in 1965, 1966, and 1967. His 1965 sprint of 19.3 seconds in the 180-yard low hurdle is still a Pennsylvania state record. In 2000, White (right) was named to the Ohio State University All-Century Team. (Courtesy of Chris Mulligan and Buckeye Empire.)

41

James "Jimmy" Jones

In a game against York High during his sophomore year at John Harris High School, Jimmy Jones broke vertebrae in his neck when he came up from his safety position to tackle a ball carrier. He spent five months in traction, a body cast, and a neck brace. When Jones began training for the upcoming football season, the school doctor suggested it was too risky to play. His coach George Chaump (page 38) took Jones to see several specialists who all said his neck was stronger than ever. Before John Harris's opening game in 1966, the doctors' testimony was presented to the school board, who subsequently voted to allow Jones to play. Jones went on to quarterback the Pioneers to two undefeated seasons and two league championships (1966 and 1967). He passed or rushed for over 2,300 yards and had 20 touchdowns as a junior and over 2,400 yards and 40 touchdowns as a senior. In his final high school game played against archrival William Penn, Jones completed 19 of 32 passes, threw for 398 yards, a state record eight touchdown passes, and one rushing score. His 35 touchdown passes in 1967 was a state single-season record until 1997. Including the games he played before his injury during his sophomore year, Jones's John Harris teams were 33-0 during his career. Jones was a First Team High School All-American and accepted a scholarship to the University of Southern California, where he earned the starting job his sophomore year. The accomplishment landed him on the September 29, 1969, cover of *Sports Illustrated* for becoming the first African American quarterback at a predominantly white college. During his sophomore year, the Trojans finished 10-0-1 and ranked third in the country after they defeated the University of Michigan in the Rose Bowl. Throughout his career at USC, Jones enjoyed classic victories over NFL greats Jim Plunkett and Joe Theisman. Arguably, his most dominating performance was a 41-21 victory in 1970 over the all-white University of Alabama. He set 13 passing records at USC as a starter. Regrettably, the NFL was not yet ready for a black quarterback. Jones played in the Canadian Football League from 1973 to 1979. He helped the Montreal Alouettes win the Grey Cup in 1974. Jones returned to Harrisburg in 1980 to enter the ministry. Concentrating on youth development, he still serves as a minister for the Church of Truth.

Carl Beck and Harrisburg Tech Football and Basketball Teams 1917–1919

Harrisburg Tech, a preparatory high school located on Walnut Street, boasted the most successful football and basketball teams in Harrisburg's history from 1917 to 1920. The star athlete at the school was Carl Beck (1897–unknown). Following an 11-0 season in 1918 in which Harrisburg Tech outscored their opponents 724 to 10, Beck and the Maroons won the high school national championship in 1919. Beck scored 34 touchdowns and helped his team go 11-0 while scoring 701 points to their opponents' zero points. Walter Camp called the 1919 team the "Champion of America." Their shut out season included dominating wins over Baltimore Poly, Bethlehem Prep, and Erie. The Maroons also defeated local rival Steel High 70-0. Beck helped his team defeat Portland, Oregon, 56-0 in the purported national championship game that was played on Harrisburg's City Island on December 6, 1919. After high school, Beck attended West Virginia University, Bucknell University, and Lafayette College. He played in the American Football Association, (present-day National Football League) for the Buffalo All-Americans, Pottsville Maroons, and the Frankford Yellow Jackets. Beck played on the 1925 Pottsville team that won the NFL Championship. Carl Beck also played basketball at Harrisburg Tech. He is pictured here in 1918 with the first Central Pennsylvania League Championship team. From left to right are the following: (first row) *Patriot-News* All Century All Star Charles "Buddy" Lingle, captain Fred Huston, and Harry Miller; (second row) Coach Miller, Carl Beck, Anthony Wilabach, manager Glenn Beard, Dan Coleman, John Smith, and faculty manager Professor Grubb. During Beck's senior basketball season in 1920, Harrisburg Tech won the Pennsylvania State Championship.

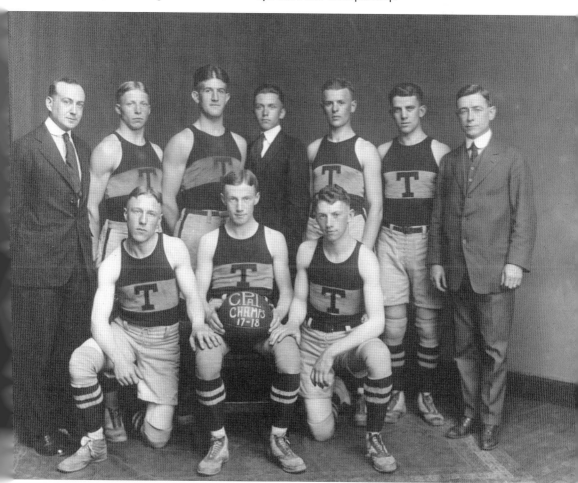

Harry Chapman III

As a young man living in the city of Harrisburg, it seemed impossible to not get caught up in the game of football, which served as the pastime for most children that heard stories about the dominant Harrisburg Tech teams of the 1910s and 1920s. Although from Newport News, Virginia, Harry Chapman III, born June 2, 1942, is a staid Harrisburger who grew up most of his life on Wayne Street. He attended Shimmell Elementary School, Edison Junior High, and ultimately graduated from John Harris High School in 1961.

All four years at Shippensburg University, Chapman excelled in football, basketball, and track and field. He returned to Harrisburg in 1966 to be an assistant coach at John Harris under legend George Chaump (page 38) and later Mickey Minnich (page 39). In the spring of 1971, Chapman was hired as the head coach at Cumberland Valley High School, a school with a football team that was just 17 years old and had yet to establish itself as a respectable program. After 18 years as the boss, Chapman created a football dynasty at Cumberland Valley. He earned a 151-48-3 overall record, five Capital Area Conference titles (1974, 1976, 1977, 1979, 1980), three Mid-Penn Conference Division I titles (1984, 1985, 1987), and two Class-AAA District 3 championships (1982, 1984). Chapman's Cumberland Valley team played in the first ever AAA District 3 Championship in 1982. The Eagles played Steelton-Highspire in front of a record crowd of 16,000 at Hersheypark Stadium. Cumberland Valley, quarterbacked by Chapman's son, Harry Chapman IV (page 46), won the game 14-12. Chapman and his son are pictured here.

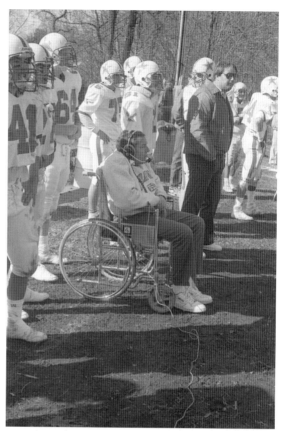

As shown in the first photograph, Harry Chapman III coached his final season in 1988 from a wheelchair. Standing to his left is his successor as head coach of the Cumberland Valley Eagles, Tim Rimpfel. Originally standing 6 feet 4 inches, Chapman had shrunk to nearly 5 feet 8 inches as he suffered from bone cancer. He died on March 22, 1989. A few months after he passed, Cumberland Valley honored Chapman by naming the football field Harry Chapman Field during a ceremony before the 1989 opening game. The second photograph is of Chapman's family. From left to right are Kathy (wife), Harry "Four" (son), and Elizabeth "Beth" (daughter).

Harry "Four" Chapman and the 1995 Bishop McDevitt State Championship Team
"Four" Chapman will always be remembered as the football coach who guided the Bishop McDevitt Crusaders to the school's modern era of dominance. In 1995, Chapman's Crusaders won the PIAA Class-AA State Championship. Notwithstanding Bishop McDevitt's dominance from 1995 to present, winning the state championship is the one thing that the program has failed to accomplish since Chapman's departure. Born October 29, 1964, in Harrisburg, Chapman attended city schools before moving into the Cumberland Valley School District. At Cumberland Valley, he played quarterback and defensive back for his father, Harry Chapman III (page 44). In 1982, Chapman led the Eagles to the first ever Class-AAA District 3 Championship. He was picked to play quarterback in the 1983 Big 33 Classic. At 26 years old, Chapman was hired to be the head coach at Bishop McDevitt High School in 1991. He inherited a program that went 8-25 during the three previous seasons. Chapman's team went 2-9 in his inaugural season. It was a speedy climb uphill after that. He implemented a change in the way McDevitt played offense. A no-huddle pass attack was installed to fit the athletic ability of McDevitt's skill players. Between 1992 and 1994, McDevitt had seasons with 8 wins, 9 wins, and 7 wins, respectively. Then, in 1995, Bishop McDevitt earned an undefeated 15-0 record. The 1995 team won the Mid-Penn Championship, Class-AA District 3 Championship, and PIAA Class-AA State Championship. In 1996, the Crusaders went 12-2 and repeated as Mid Penn and Class-AA District 3 champions. Chapman's 1997 team was 10-3 and won its third consecutive Class-AA District 3 title. He acquired a 63-23 record in seven seasons at McDevitt. Chapman resigned after the 1997 campaign.

Tim Rimpfel

Tim Rimpfel retired from a long career as a head football coach in December 2012. Rimpfel stepped away after 43 years and 308 wins, including 11 total District 3 Championships and one PIAA Quad-A State Championship. Rimpfel grew up in Steelton and graduated from Bishop McDevitt High School in 1965. He became the first in his family to attend college. He graduated from West Chester in 1969. During his senior year at West Chester, Rimpfel was hired as an assistant coach at Trinity High School, where he worked as an assistant from 1969 to 1976 and head coach from 1977 to 1979. He was Trinity's athletic director from 1980 to 1981. By chance, the position of head coach at his alma mater came open in the summer of 1981, and Rimpfel was sought after for the position. That July, Rimpfel accepted the job, and he served as Bishop McDevitt's head coach from 1981 to 1987. At McDevitt, Rimpfel won two Class-AA District 3 titles in 1985 and 1987, respectively, and won the South Central League in 1983. He was fortunate to coach many great athletes at McDevitt, including Rickey Watters (page 61), who helped him compile a 55-24-1 record. In 1987, Rimpfel left McDevitt to work as athletic director at Cumberland Valley High School. In 1989, he became Cumberland Valley's head football coach. He remained in that position for 24 years. At Cumberland Valley, Rimpfel won nine Quad-A District 3 championships and one PIAA Quad-A State championship (1992). Rimpfel and his football players were noticeable servants to their community. His Cumberland Valley teams helped build Adventure Park in Mechanicsburg and participated in several fundraising ventures with the Four Diamonds Foundation. When Rimpfel retired in 2012, he was one of just 10 coaches in Pennsylvania to earn more than 300 wins. He has been a Big-33 head coach (2011), has been named Pennsylvania Big School Coach of the Year, has been inducted into the West Shore Sports Hall of Fame (1993), and was inducted into the Pennsylvania Scholastic Football Coaches Association Hall of Fame in 2009. This photograph shows Rimpfel on August 2, 1993, with members of his 1992 state championship team.

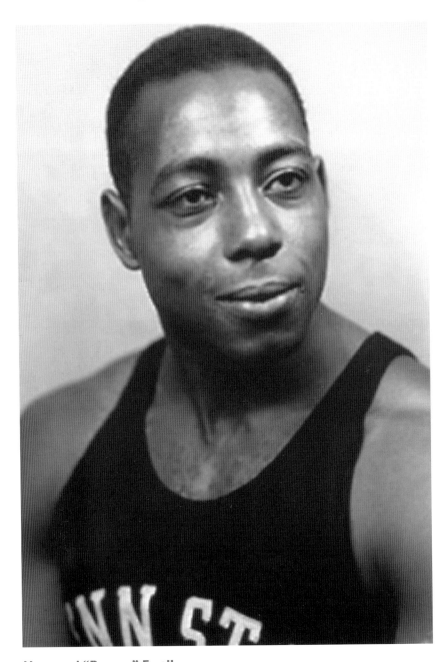

Henry Norwood "Barney" Ewell

"Barney" Ewell (1918–1996) is known for winning a Gold Medal and two Silver Medals in London at the 1948 Olympics. He was 30 years old in those games. Many believe Ewell could have gone down as one of the Olympics' all-time medal winners in track and field if the games would have been held in 1940 and 1944 instead of being cancelled by World War II. Ewell was born in Harrisburg but moved to Lancaster, Pennsylvania, in the early 1920s. He was a three-time state champion at McCaskey High School and a 12-time NCAA sprint champion at Penn State University. His All-American career at PSU was interrupted in 1942 after he was drafted into the Army. Ewell served the duration of World War II, plus six months in the segregated infantry. (Courtesy of Michelle Laws.)

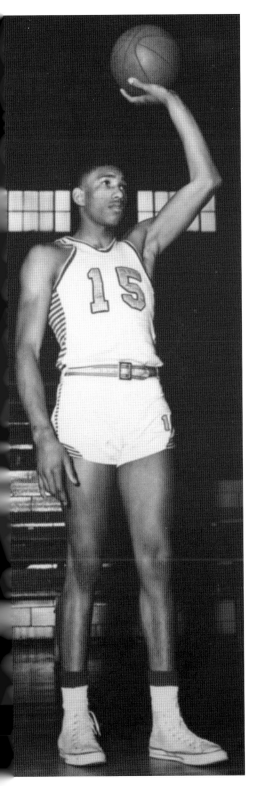

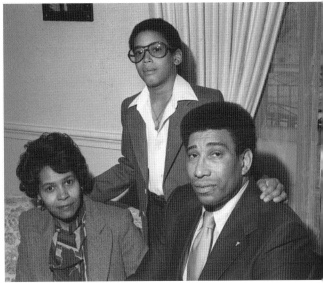

Julius McCoy

Nicknamed "Hooks" for his large hands and hook shot, Julius McCoy (1932–2008) was a basketball player well ahead of his time. His ability to play above the rim made him the all-time leading scorer and an All-American at Michigan State University. In 1956, the Saint Louis Hawks of the NBA drafted him. He was drafted into the Army in the same year. He returned to civilian life in 1958 and entered the Eastern Basketball League. McCoy lasted 13 years in the EBL. During that time, he moved to Harrisburg. McCoy worked as director of physical education for the Harrisburg YMCA. From 1971 to 1983, he was the basketball coach at John Harris, later Harrisburg High School. McCoy is pictured in February 1981 at his Bellevue Park home with his wife and son. (Courtesy of Jim Raykie.)

Nick Horvath Jr.
Pictured with Bob Davies (page 65), Horvath first worked at the *Patriot-News* during his sophomore year at Bishop McDevitt High School. After earning degrees from the University of Oklahoma, Horvath was hired full-time by the *Patriot* in 1972 to cover horse races at Penn National. From 1984 to 2009, he was the newspaper's sports editor. Horvath was responsible for creating innovative layouts that fed the community's hunger for high school sports.

Andrew Linker
Starting in 1984, Andy Linker was a *Patriot-News* baseball columnist for 24 years. In 1993, he attained his signature role with the *Patriot* when he was given the job as beat writer for the Harrisburg Senators. The image shows Linker in his home in 2013 upon retirement. (Author's collection.)

Timothy Foreman

Tim Foreman was hired as the general manager of the Harrisburg Senators in 1993. His first duty was to manage the cleanup of the ballpark after the filming of the movie *Major League 2*. In 1998, he was promoted to facilities manager. These days, as director of stadium operations at Metro Bank Park, Foreman experiences one problem that no other stadium director in Pennsylvania has to deal with—flooding. Of the National Weather Service's top 30 floods, Foreman and the ballpark have endured 13 of the worst. The most horrible flood occurred in September 2012 (pictured), when eight feet of water and seven inches of mud swamped the island. (Courtesy of Sean Simmers and author's collection.)

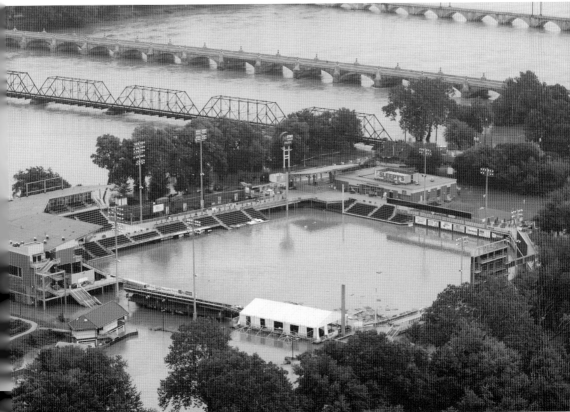

Harry DeFrank

On October 25, 2009, the Pennsylvania Sports Hall of Fame held its 47th induction ceremony. Of the 12 persons inducted, one was the late Harry DeFrank (1926–2007) who was a basketball coach in Harrisburg for much of his life. He began as a coach at St. Francis Elementary School and Good Shepherd Elementary School before the athletic department at Trinity High School hired him to become the head girls' basketball coach in 1984. After a 23-year career, DeFrank earned an overall record of 585-127, including nine AA District 3 Championships and two PIAA AA State Championships.

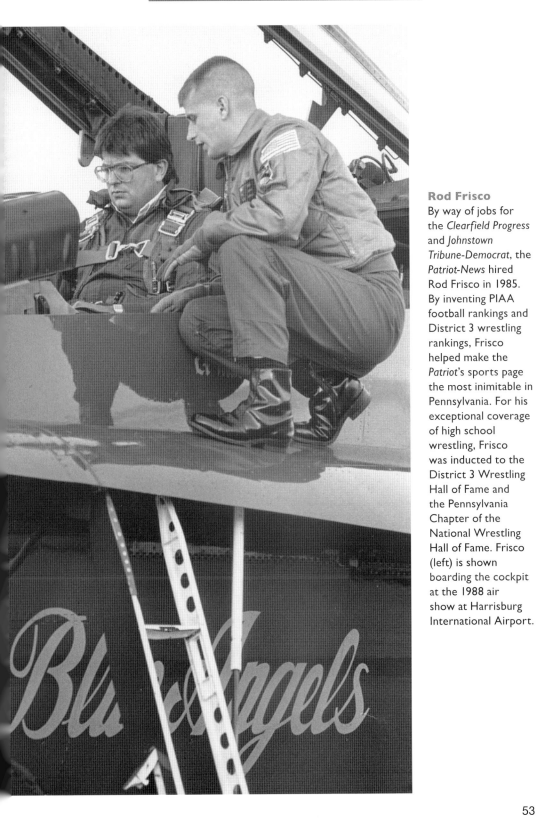

Rod Frisco
By way of jobs for the *Clearfield Progress* and *Johnstown Tribune-Democrat*, the *Patriot-News* hired Rod Frisco in 1985. By inventing PIAA football rankings and District 3 wrestling rankings, Frisco helped make the *Patriot*'s sports page the most inimitable in Pennsylvania. For his exceptional coverage of high school wrestling, Frisco was inducted to the District 3 Wrestling Hall of Fame and the Pennsylvania Chapter of the National Wrestling Hall of Fame. Frisco (left) is shown boarding the cockpit at the 1988 air show at Harrisburg International Airport.

Rob Deibler and the 2007 and 2008 Steel-High State Championship Teams
Not everyone can say that Tom Coughlin, who is currently the head coach of the New York Giants, once recruited them. Neither can they say they have spent a weekend with Doug Flutie while on a recruiting visit to Boston College. During his senior year at Steelton-Highspire in 1983, Rob Deibler was sought after by Coughlin, who was the quarterbacks coach at Boston College University, where Flutie was in the middle of his senior season. Deibler was also recruited by Memphis State, Florida, and Minnesota before finally choosing to accept a full scholarship to Rutgers University. For three seasons, Deibler quarterbacked Steel-High football teams that went 30-4-1, lost in the AAA District 3 championship in 1982, and won the AAA District 3 championship in 1983. In 1984, Deibler was a quarterback in the Big 33 Classic. He spent just one season (1984) at Rutgers before transferring to Indiana University of Pennsylvania to play for legend George Chaump (page 38)

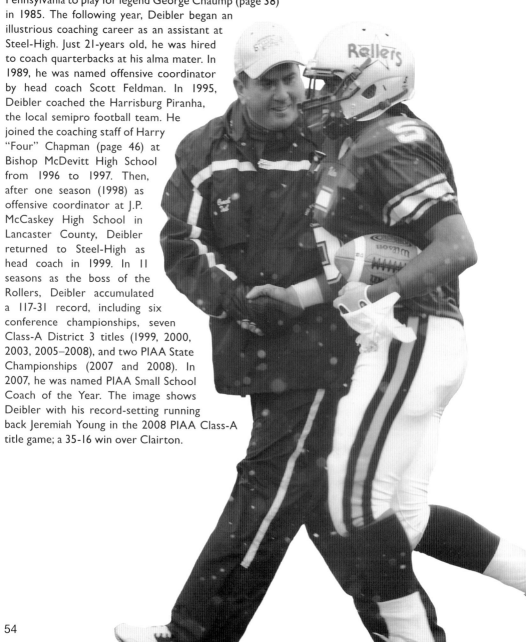

in 1985. The following year, Deibler began an illustrious coaching career as an assistant at Steel-High. Just 21-years old, he was hired to coach quarterbacks at his alma mater. In 1989, he was named offensive coordinator by head coach Scott Feldman. In 1995, Deibler coached the Harrisburg Piranha, the local semipro football team. He joined the coaching staff of Harry "Four" Chapman (page 46) at Bishop McDevitt High School from 1996 to 1997. Then, after one season (1998) as offensive coordinator at J.P. McCaskey High School in Lancaster County, Deibler returned to Steel-High as head coach in 1999. In 11 seasons as the boss of the Rollers, Deibler accumulated a 117-31 record, including six conference championships, seven Class-A District 3 titles (1999, 2000, 2003, 2005–2008), and two PIAA State Championships (2007 and 2008). In 2007, he was named PIAA Small School Coach of the Year. The image shows Deibler with his record-setting running back Jeremiah Young in the 2008 PIAA Class-A title game; a 35-16 win over Clairton.

Kirk Smallwood

Smallwood took over reigns of the Harrisburg basketball team in 1993, and has since led them to two PIAA Class-4A state championships (1998, 2002), seven PIAA Class-4A District 3 championships (1996, 1998, 1999, 2003, 2006, 2007, 2013), and 17 Mid Penn championships. In 2012, Smallwood attained his 500th victory, placing him in a rare group of coaches who have achieved that mark. Smallwood is shown here in 1993.

Vincent Boulware

Known as the "Harrisburg Hitman," Vincent Boulware started his career as a member of the Harrisburg Boxing Club. A former sparring partner for George Foreman and Lennox Lewis, Boulware became a four-time Pennsylvania Golden Gloves champion (1981–1984). He won the USA Texas State light heavyweight title, USBA light heavyweight title, IBC Continental Americas Cruiserweight title, IBC Cruiserweight title, and challenged for three world-boxing championships.

Glenn McNamee and the 2011 Central Dauphin State Championship Team

The Central Dauphin Rams 2011 PIAA 4A State Championship was certainly one of the most unexpected major accomplishments in Pennsylvania football history. An unassuming five-year head coach named Glenn McNamee led them. Known for his humility and integrity, McNamee's 2011 team was a product of his good fortune. Heading into the season, the Rams were missing 23 seniors from the previous year, and had just two starters back on defense and four on offense. The Rams were defeated in their pre-season scrimmages and opened the regular season 1-1 before going on a 14-game win streak. During that stretch, the Rams defeated Wilson West Lawn for the Class-4A District 3 Championship and North Penn 14-7 for the PIAA Class-4A State Championship. McNamee was named Pennsylvania Sports Writers' 2011 Class-4A Coach of the Year.

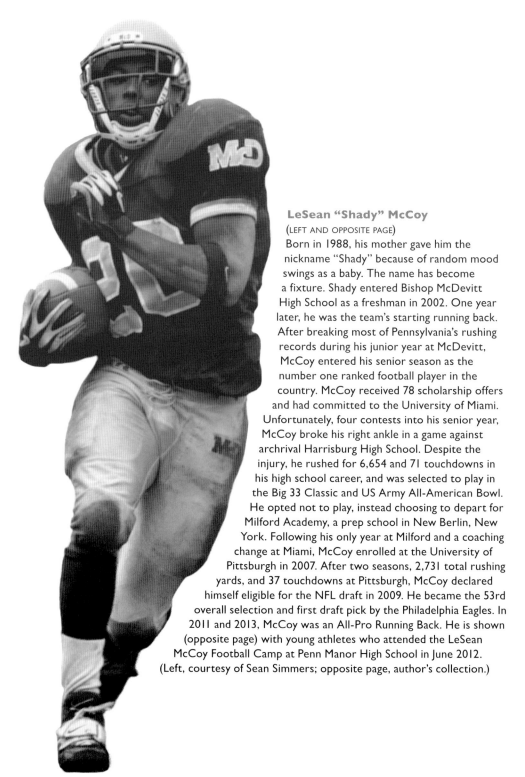

LeSean "Shady" McCoy

(LEFT AND OPPOSITE PAGE)

Born in 1988, his mother gave him the nickname "Shady" because of random mood swings as a baby. The name has become a fixture. Shady entered Bishop McDevitt High School as a freshman in 2002. One year later, he was the team's starting running back. After breaking most of Pennsylvania's rushing records during his junior year at McDevitt, McCoy entered his senior season as the number one ranked football player in the country. McCoy received 78 scholarship offers and had committed to the University of Miami. Unfortunately, four contests into his senior year, McCoy broke his right ankle in a game against archrival Harrisburg High School. Despite the injury, he rushed for 6,654 and 71 touchdowns in his high school career, and was selected to play in the Big 33 Classic and US Army All-American Bowl. He opted not to play, instead choosing to depart for Milford Academy, a prep school in New Berlin, New York. Following his only year at Milford and a coaching change at Miami, McCoy enrolled at the University of Pittsburgh in 2007. After two seasons, 2,731 total rushing yards, and 37 touchdowns at Pittsburgh, McCoy declared himself eligible for the NFL draft in 2009. He became the 53rd overall selection and first draft pick by the Philadelphia Eagles. In 2011 and 2013, McCoy was an All-Pro Running Back. He is shown (opposite page) with young athletes who attended the LeSean McCoy Football Camp at Penn Manor High School in June 2012. (Left, courtesy of Sean Simmers; opposite page, author's collection.)

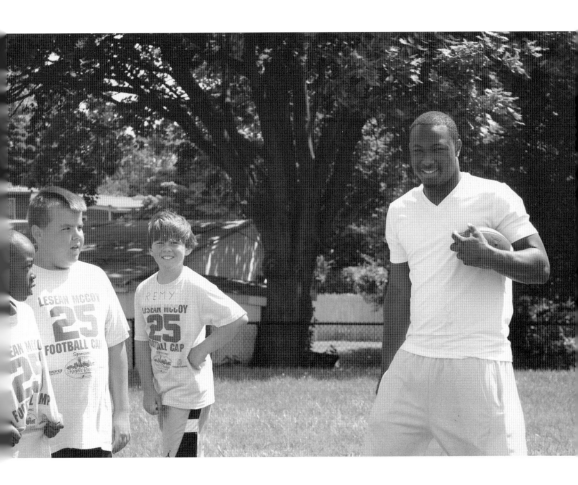

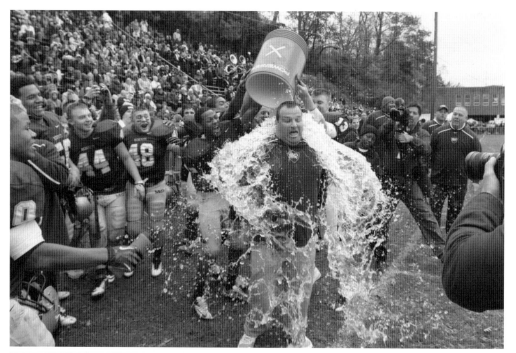

Jeff Weachter

The above photograph shows Jeff Weachter and his players on November 3, 2012, celebrating Bishop McDevitt's final victory at historic McDevitt Stadium before relocating to a new facility the following year. McDevitt's athletic department in 1998 hired Coach Weachter. Between 1998 and the time this book went to print, Weachter attained a 153-48 record as the Crusaders' head coach, becoming the school's all time wins leader. His teams have won seven Mid Penn Conference titles and six PIAA District 3 championships, including three titles each while competing in class Quad-A and Triple-A. The Crusaders have played for the PIAA Triple-A State Championship three times with Weachter as their coach—finishing runner-up in 2010, 2011, and 2013 respectively. In the second photograph, Weachter is shown with quarterback Matt Johnson in a 2009 game. (Both courtesy of Vickie Vellios Briner.)

Ricky Watters

People who lived in Harrisburg during the 1980s still argue that Ricky Watters (born 1969) is one of the most talented running backs to ever play football in Pennsylvania. As a young athlete, Watters played for the Harrisburg Packers and Our Lady of the Blessed Sacrament. He played high school football at Bishop McDevitt High School, where he was an All-American and Pennsylvania Big-33 All Star. In 1987, he was the top-rated recruit in the country. Watters committed to the University of Notre Dame and was a freshman contributor on the Fighting Irish's 1988 national championship team. Before he graduated, Watters was named an All-American in two positions, running back and wide receiver. He played 11 years in the NFL, including four with San Francisco 49ers, three with the Philadelphia Eagles, and four with the Seattle Seahawks. In 1994, the 49ers won Super Bowl XXIX. Watters scored three touchdowns in the game. He played in five Pro Bowls and is the only NFL running back to rush for more than 1,000 yards in a season for three different teams. Watters is pictured above signing autographs for students at Saint Theresa School in New Cumberland.

Robert Tate

"Pint" Tate (far left) was a star football and basketball player at Harrisburg High School, class of 1992. Known for amazing sprints to the end zone as a running back and alley-oop passes off the backboard to teammate Dan Buie as point guard for the Cougars, Tate was drafted by the Minnesota Vikings in 1997. He played nine years in the NFL with the Minnesota Vikings, Baltimore Ravens, and Arizona Cardinals.

Hyleas Fountain

Hyleas Fountain is a graduate of Central Dauphin East High School, class of 2000. Fountain is a four-time NCAA championship in the heptathlon (2003) and long jump (2004) while at the University of Georgia. She is one of the top heptathletes in the world, having won a silver medal in the 2008 Olympic Games in Beijing and qualifying to compete in the 2012 Olympics in London.

Rusty Owens

Rusty Owens is shown coaching swimmers in 1982. During his career, he also coached swimmers in the Marine Corps, Lebanon Valley College, the Hershey Aquatic Club, and at the Harrisburg YMCA. He has coached two local swimming Olympians, Anita Nall and Jeremy Linn. In 2010, the International Swimming Hall of Fame awarded the G. Harold Martin Award for "Every Child A Swimmer" to Owens. (Courtesy of Paul Chaplin.)

Ben Olsen

DC United coach Ben Olsen is a Harrisburg native once considered among the country's top soccer players. In 1993, he was named *Parade*'s National High School Player of the Year. He was part of winning two ACC soccer titles at the University of Virginia. Olsen played professionally from 1998 to 2009 for DC United, where he won two MLS Cups (1999 and 2004). (Courtesy of dcunited.com and Tony Quinn.)

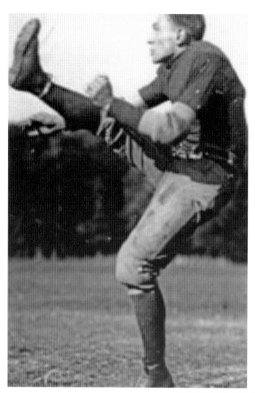

W. Glenn Killinger

Glen Killinger (1898–1988) is remembered as one of Harrisburg Tech's most astonishing athletes. He was considered too small to start on his high school football team, but he later became an All-American quarterback at Penn State. He never lost a game, compiling a 15-0-4 record. Killinger earned nine varsity letters in football, basketball, and baseball. He was inducted into the PSU Athletic Hall of Fame in 1971.

Gary Ross

Perhaps the greatest athlete to graduate from William Penn High School is Gary Ross. In fact, Harrisburgers today debate whether Rickey Watters (page 61), LeSean McCoy (page 58), or Ross is the city's greatest football talent. Ross's sheer size and athleticism struck fear into his opponents. Ross also played basketball, and in 1963 he helped the Tigers win the PIAA District III Class-A championship.

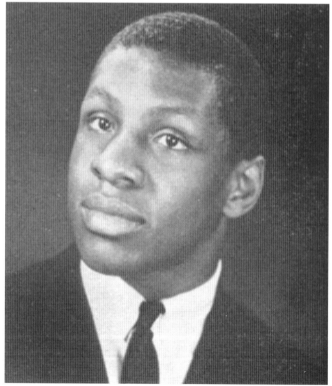

Robert "Bob" Davies and Richard "Dick" Davies

Arguably, the most talented basketball players to come from Harrisburg were the Davies brothers. Bob Davies (1920–1990) was originally recruited to play baseball but instead excelled at basketball while at Seton Hall. Known as a master ball handler who possibly invented the behind-the-back dribble, Davies led the Pirates to 43 consecutive wins and an overall record of 55-5 from 1939 to 1942. After Pearl Harbor, Davis left Seton Hall and entered the Navy. He played basketball with the Great Lakes Naval Station in 1942, helping his team to a 34-3 record. Professionally, Davies played for the Rochester Royals. He was named Rookie of the Year in 1945. In 1947, he was named the National Basketball League's MVP. Davies was inducted into the Basketball Hall of Fame on April 11, 1970. Likewise, his younger brother had ample opportunity to play in the NBA, choosing another basketball path instead. Dick Davies (1936–2012) first enrolled at Gettysburg College, where his brother Bob was coaching. At the start of his junior year, he transferred to play guard at Louisiana State University, where he became a captain. Drafted by the St. Louis Hawks in 1960, Dick instead chose to play for the Akron Goodyear Wingfoots of the Amateur Athletic Union. This allowed him to participate in the 1964 Olympic games. His USA team went 9-0 and won the gold medal. Before his basketball career ended, Dick Davies played for four Hall of Famers: his brother at Gettysburg College, Red Auerback of the Boston Celtics, and Hank Iba and John McLendon in the 1964 Summer Olympics. This image shows the Davies brothers at the Penn Harris Motor Inn for Dick's (right) induction into the State Hall of Fame, November 15, 1980.

Al Chambers

Al "Choo Choo" Chambers, an imposing 6 foot 4 inches, 215-pound outfielder, became Harrisburg's only first overall draft pick in professional sports when he was selected by the Seattle Mariners in 1979. Pictured with Harvey "Haps" Boyer (page 100) at the opening ceremony of the Central Penn Midget Tournament in July 1989, Chambers played for Seattle's farm team in Salt Lake City for four years before being brought up to the Mariners on July 22, 1983. In his first game, Chambers drove in four runs against the Boston Red Sox. He played professionally in Seattle for a total of 57 games and 120 at-bats in 1983, 1984, and 1985. After short tenures with the Cubs, Rangers, and White Sox organizations, Chambers ended his baseball career in 1995.

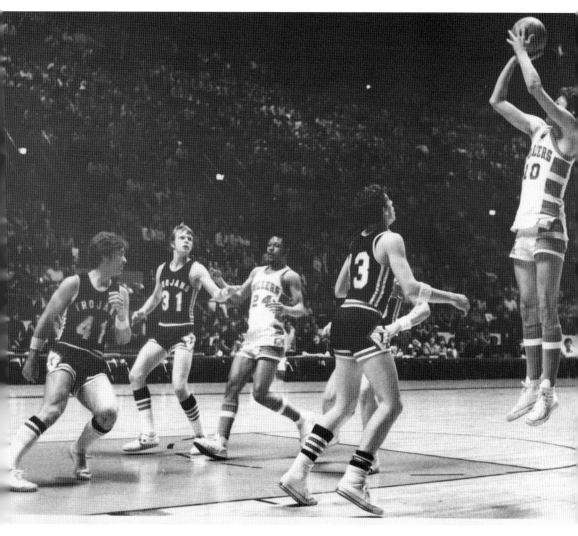

Greg Manning

A member of the 1977 Central Penn League championship team and runner-up in the AAA Pennsylvania State Basketball Championship, Greg Manning was a star shooting guard for the Steel-High Rollers. His most memorable single-game performance fell on March 20, 1977, when he scored 57 points in a playoff game against Nanticoke. The Rollers won 87-83. In the game, Manning shot 25 for 28 from the floor and 7 for 8 from the foul line. Remarkably, Manning suffered from the flu that game. During his senior year (1976–1977), Steel-High averaged a school record 88.9 points per game while accumulating 29 wins and 3 losses. At a time when there was no three-point arc, Manning scored 859 points in 32 games during his senior year. He was selected First Team AP All-State and First Team UPI All State. He earned a basketball scholarship at the University of Maryland, where he started all four years as a guard, was a team captain, scored more than 1,000 points, and was a three-time All ACC Academic all star. On the opposite page, Manning (right) is shown at the Steelton High Sports Dinner at Hershey Hotel on May 29, 1977. He stands with University of Maryland coach Lefty Driesell (left) and Adolph DeFillipo (center).

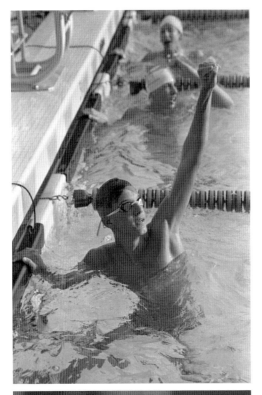

Jeremy Linn
Pictured here in 1993 as a swimmer at Central Dauphin, Jeremy Linn was SEC "Swimmer of the Year" three times at the University of Tennessee. As a breaststroke swimmer, Linn won 17 All-American honors and helped the Volunteers win the 1996 SEC championship. At the 1996 Olympic Games in Atlanta, Linn won the silver medal in the 100-meter breaststroke and a gold medal in the 400-meter medley relay.

Marques Colston
Marques Colston is the all-time leading receiver for the New Orleans Saints. Colston attended Susquehanna Township High School, then Hofstra University, and finally was drafted by the Saints in 2006. Colston finished second in votes for the NFL's Rookie of the Year. In 2009, he was a 1,000-yard receiver and helped the Saints win Super Bowl XLIV with seven receptions for 83 yards. (Courtesy of Sean Simmers.)

Chris "Handles" Franklin

Chris Franklin embodies the youth who constitutes the majority of American society—a young man who never gave up on his dream and became a member of the Harlem Globetrotters. Over many years, Franklin has used his position with the Globetrotters to work outside the box to raise awareness about Hurricane Sandy recovery and speaking about the ABCs of Bullying, a program encouraging school children to report bullying. A star basketball player at Susquehanna Township High School, Charles "Handles" Franklin has become one of the most popular Harlem Globetrotters of the new millennium. Before joining the Globetrotters, Franklin attended Lock Haven University, where he became the school's second all-time assist leader and ranked top 10 NCAA Division 2 in assists and steals. After college, he entered a Nike top dribbler competition and won first place, granting him the moniker "best ball-handler in the world." He was asked by Nike to participate in a commercial called "Freestyle." The commercial went on to win 12 awards and earned Chris a contract with Nike, including roles in commercials with NBA players Vince Carter and Lebron James. He joined the Globetrotters in 2007. Since 2001, he has hosted the Ultimate Spin Basketball Camp for youngsters in Harrisburg. In 2012, a year after Hurricane Sandy destroyed the Jersey Shore, Franklin spearheaded the Globetrotters' "Stronger Than the Storm" campaign by appearing on NBC's *Today Show* and *Good Morning America*. He has helped produce and star in a video that shows him performing ball-handling tricks in front of a dozen seashore icons along the east coast. On June 17, 2013, Franklin and his teammates conducted a 7.7-mile dribble-walk from Baltimore to Towson as part of the Globetrotters' anti-bullying campaign, of which Franklin has spoken at schools across the country. (Photograph by Dale Gerhard, courtesy of Press of Atlantic City.)

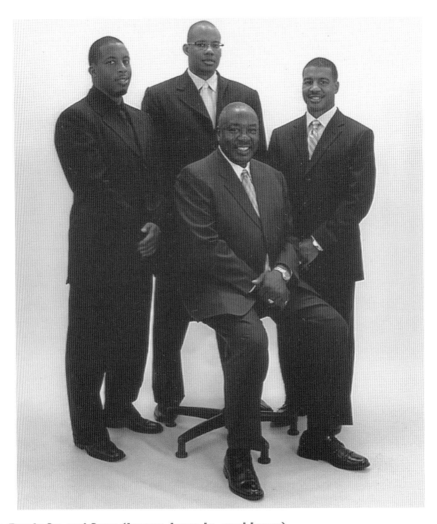

Jesse Rawls Sr. and Sons (James, Jesse Jr., and Jason)
The Rawls men boast a story unmatched by virtually every family in the United States. All four were wrestlers of the highest caliber in Pennsylvania, and each went on to earn scholarships to the University of Michigan. The family patriarch is Jesse Rawls Sr., born in 1947 at Guyton, Georgia. At the age of 17, he left his home in the South to move in with an uncle in Harrisburg. Having never before played competitive sports, Jesse Sr. made the football and wrestling teams at John Harris High School. While an exceptional football player, Jesse dominated as a wrestler. During his senior year in 1966, he earned a 25-0 record and won the PIAA state championship. Jesse Sr. first enrolled at Trinidad State Junior College in Colorado. After he won the 1968 NJCAA national championship, legendary coach Cliff Keen recruited him to the University of Michigan. Jesse Rawls Sr. became the first African American to be given a scholarship to wrestle at UM. By the end of his college career, Jesse Sr. had won the NJCAA national championship, was an NJCAA and NCAA All-American, ranked as high as third in the NCAA, and was the 1969 Big-10 wrestling champion. In 1993, he was inducted into the National Junior College Hall of Fame. In 1989, his oldest son, James, won the PIAA state title at Susquehanna Township High School. Also from Susquehanna, his second son Jesse Jr. won the PIAA state championship in 1991 and became a two-time NCAA All-American at Michigan. His youngest son, Jason, was a two-time PIAA District 3 champion while wrestling at Harrisburg High School. Pictured above is Jesse Rawls Sr. with sons (from left to right) Jason, Jesse Jr., and James. (Courtesy of Jesse Rawls Sr.)

CHAPTER FOUR

Business Leaders, Artists, Photographers, and Writers

Harrisburg was one of the most economically distressed cities in Pennsylvania in the 1980s. The economic decline began after World War II when city residents moved to the suburbs. To make matters worse, the Three Mile Island nuclear meltdown in 1979 resulted in the loss of billions of dollars as more people left Harrisburg fearing radiation leaks from the accident. The situation in Harrisburg began to change once pro-business Democrat Stephen R. Reed was elected mayor. The period of Reed's election and the end of the 20th century, Harrisburg experienced a significant crime rate reduction and revitalization to the city's downtown. *Forbes* in 2004 rated Harrisburg 11th for "Best Crime Rate in the Nation." The Dauphin County Historical Society reports over 9 million feet of business land was developed in the city's center. In 2005, there were 6,951 businesses in Harrisburg. This chapter profiles important restaurants, family-owned shops, photographers, artists, and writers who have contributed to the growth of Harrisburg, thus making it a chief example of urban resiliency.

Donald L. Brown Jr.
Born in Harrisburg in September 1961, "Donny" Brown has become one of the most flourishing restaurant owners in Harrisburg. After 30 years in the business, he has employed hundreds workers and served an incalculable number of customers. Brown is the owner of Firehouse, one of the bookends of Harrisburg's "Restaurant Row" along Second Street. Beginning in 1984, Donny and his father went into the restaurant business together, starting with Paradise Alley in the Harrisburg East Mall. The father-son duo also co-owned Club Med, Zephyr Express, and Kokomos in Camp Hill. In 1997, Donny opened Firehouse. He has also owned Fisaga in Harrisburg, Fire Alley in Hershey, and Black N Blue in Mechanicsburg. As owner of Firehouse, Brown has been awarded *Harrisburg Magazine*'s Restaurant Tour of the Year and Harrisburg Young Professionals Businessman of the Year. (Author's collection.)

Paul Beers

When it comes time to have one's life summed up in fine print, one can only hope that you have left footprints—or in Paul Beers's case—text that can be seen by Harrisburgers for years to come. Paul Beers (1931–2011) was an award-winning journalist for the *Patriot-News*. He first joined the *Patriot* in 1957. Beers published five books about Pennsylvania people and politics, and in 1981, was named associate-editor of the *Patriot* and *Evening News*. He is celebrated most for his "Reporter at Large" column that won him numerous awards for journalism. In 1985, he resigned from the *Patriot* to become a legislative historian for the commonwealth. In one last column announcing his retirement on December 30, 1985, Beers revealed that he had written 3,599 columns and more than three million words during his 25-year tenure at the newspaper. Several of his columns have been turned into a book titled *City Contented, City Discontented* edited by legendary local Dr. Michael Barton.

Sara Ganim

Sara Ganim was born in Detroit, Michigan, raised in Ft. Lauderdale, Florida, and attended Penn State University. She arrived in Harrisburg to work as a crime reporter for the *Patriot-News* in January 2011. In 2012, Ganim won the Pulitzer Prize for local journalism after she broke a story about the Jerry Sandusky sex abuse scandal. She was just 24 years old. Within a year at the *Patriot*, she had become the recipient of the Distinguished Writing Award for Local Accountability Reporting from the American Society of News Editors, the Scripps Howard Award for Community Journalism, the George K. Polk Award, the Sidney Award, and the Pulitzer. In 2012, *Newsweek* named Ganim one of 150 Fearless Women in the World. (Courtesy of Sean Simmers.)

C. Ted Lick

Lick (1924–2011) was the owner of the Harrisburg Paper Company, a wholesale distributor of paper products founded by his father, Clarence Lick, in 1933. In 1973, Lick was voted Boss of the Year by the American Businesswomen Association for his advocacy for gender equality. He was also known for being at the forefront of providing performance bonuses to his employees. Lick was a world-traveling big-game hunter. The Harrisburg Area Community College named its Wildwood Conference Center after Lick, who is pictured on a hunting expedition in 1975. The Lick Tower Building on North Sixth Street is named in his honor.

Georg R. Sheets

Since 2007, Georg Sheets has worked as the publisher of *ShowcaseNow!*, a magazine that promotes literature, art, culture, heritage, and tourism in nine counties of Central Pennsylvania. *ShowcaseNow!* has nearly 100,000 readers and is available in 350 coffee shops, hotels, restaurants, and fitness centers. Sheets originally arrived in Harrisburg in 1996 to work as the executive director of the Dauphin County Historical Society.

Rogele, Inc. and James R. McClure

James McClure (1942–2001) was the owner of Rogele, Inc., Harrisburg's longest lasting family-owned construction company. He graduated from West Point in 1964 and served two tours in Vietnam. McClure ran Rogele for 40 years. The picture shows Rogele's secretary John Dando and Capt. Ron Dambrosia, assistant director of training security at the US Army War College in Carlisle, sealing the college's time capsule.

Maria Marroquin

Maria Marroquin's resilience as a business leader is unparalleled. Originally from Michoacán, Mexico, Marroquin settled with her husband Herbano "Herby" Marroquin in Steelton in 1972. They arrived less than two weeks after Hurricane Agnes devastated the area. She was unenthusiastic at first, having witnessed people in canoes floating down Front Street. She remained optimistic after attaining a job at Howard Johnson's and later Hotel Marriott. Her husband died in a tragic car accident in 1984. Left to take care of her three children on her own—her parents and siblings still living in Mexico—Marroquin took a risk. In 1986, a single parent of three with broken English and a no formal education, she quit her job at the Marriott and opened a small Mexican grocery store in Steelton. Seven days a week, Marroquin manned the grocery store, which she named Herby's after her late husband. While providing signature Mexican foods, seasoning, and spices, she cooked for her children. Customers often desired a taste of what she was preparing. That experience encouraged Marroquin to turn her grocery store into a take-out restaurant. Patrons from Steelton, Middletown, and Harrisburg frequented Marroquin's take-out shop. About 1999, she relocated to 720 Main Street in Steelton and opened a full-fledged restaurant called Herby's El Mexicano Restaurant. Her restaurant is popularly known as the oldest authentic Mexican restaurant in Harrisburg. Everything on her menu is a homemade recipe that she learned from her mother in Mexico. Her menu features a dinner called Camarones al Mojo de Ajo, yet most of her patrons buy the No. 2 Taco Dinner (seen in the picture). Today, restaurant-goers from all over Central Pennsylvania make the trip into Steelton to dine at Herby's, including former governor Mark Schweiker and Senator Bob Casey. In 2006, Marroquin cofounded the Hispanic Chamber of Commerce in Central Pennsylvania to serve as the safety net for new Hispanic business owners. She served as its first vice president. (Author's collection.)

James "Jimmy" Kaldes

For 70 years, the Spot, located on the corner of Second and Market Streets, operated as Harrisburg's landmark restaurant. Flourishing as the signature local food joint from 1939 to 2007, the Spot endured major floods, World War II, Korean War, Vietnam War, and urban redevelopment. Pictured here is owner Jimmy Kaldes. In 2009, Jimmy Kaldes, at 93 years old, passed away from liver cancer.

Grafton Tyler Brown

The son of popular abolitionists and entrepreneurs in Harrisburg, Brown (1841–1918) was the first African American lithographer and landscape painter to produce works of the Pacific Northwest and California. He migrated to California during the Gold Rush. In 1867, he established his own firm G.T. Brown & Co. Brown's most celebrated work is *The Illustrated History of San Mateo County* (1878).

Darmayne Robertson

Lifelong Harrisburg resident Darmayne Robertson is a successful cake decorator in her hometown. Born in 1963, educated within the Harrisburg School District, and a former member of the US Coast Guard, Robertson opened Sweet Confections Cakes in 1992. Originally called Confection Connection, she operated her bakery from her house for seven years. In a short time, her delectable treats and wedding cakes became a Central Pennsylvania marvel. In 2005, she moved her business into its current location on Queen Avenue. She has baked cakes for many notable individuals, including a replica 1980s boom box for actor Donnie Wahlberg, also of the New Kids On The Block, and a replica of the capitol building for Sen. Dwight Evans (D-Philadelphia). She is pictured with her husband, Willard "Robby" Robertson. (Author's collection.)

Eric Papenfuse

Located just five blocks from the Pennsylvania capitol building is the largest used bookstore in the commonwealth. In 2008, the Midtown Scholar Bookstore and Famous Reading Café moved to its current location, directly across from Harrisburg's historic Broad Street Market, in what used to be a 1920s-era theater. Established in 2001, the retail and e-commerce firm stocks over two million used, rare, and discounted books. The Midtown Scholar functions as a coffeehouse, an art gallery, and meeting place for city residents and students. It also has an upstairs lounge and performance stage. The store regularly hosts book signings, music performances, and political debates. Papenfuse's goal has always been to make the Midtown Scholar into the "destination of choice" for local authors and regional scholars. The store is renowned as the driving force for the cultural rehabilitation of Harrisburg's Midtown, especially along Third Street where the Harrisburg Midtown Arts Center and the Midtown Cinema movie theater have benefited from increased pedestrian traffic caused by Papenfuse's store. Papenfuse, a native of Baltimore, arrived in Harrisburg in 1999 when his wife, Catherine, accepted a job at Messiah College. He taught Latin at Central Dauphin East and Linglestown Junior High Schools. Deeply devoted to his adopted city, Papenfuse announced his candidacy for mayor in February 2013. The Midtown Scholar was used as a central location for his election as Harrisburg's 38th mayor in November 2013. (Courtesy of Eric Papenfuse.)

Char Magaro

Char Magaro, the visionary behind Char's at Tracy Mansion, is a modern success story, especially among Harrisburg's entrepreneurs—particularly the self-made ones. She started with few resources and built several restaurants by taking risks, listening to her intuition rather than business analysts or critics. Originally from Erie, Char has lived an intriguing life. For some time after college, she traveled to India, where she met a dance group in Haridwar, a popular pilgrimage city near the Himalayas. Her relationship with her Indian dance partners brought her to Philadelphia in the 1970s. In 1974, she arrived in the Harrisburg area and soon opened a food stand called Magaro's Imported Foods at Broad Street Market and Kline Village Market. Her food stand turned into a catering business, which, in 1981, added a deli on Third Street called Magaro's. In 2002, she opened an Italian restaurant called Char's Bella Mundo in Shipoke. Her new restaurant was among Harrisburg's most popular; and most resilient, after enduring two floods in 2006 and 2011, respectively. Realizing she had another opportunity to expand her business when the Susquehanna Real Estate Group was looking to convert the once exquisite Tracy Mansion into a restaurant, Char began the process to relocate to North Front Street. With a view of the Susquehanna River and its own sculpture garden, Char's at Tracy Mansion provides American Brasserie with Eastern influenced dishes. Char, 62, leans on an extraordinary track of personal success. Yet she has always been inspired to try new things. In the 1980s, as founder of the Pennsylvania Rainforest Action Committee, or PRAC, Char became internationally known for her environmental activism. In Harrisburg, she successfully spearheaded a movement that convinced the designers of the Harrisburg Hilton to use sustainable Pennsylvania cherry wood instead of mahogany. Internationally, she helped to prevent Scott Paper from destroying the rain forest in Philippines. In 1990, she threatened Buyers Market of American Crafts with a boycott unless they banned two tropical hardwoods from its Niche Awards competition in Atlantic City. Magaro also used her position with PRAC to organize several Earth Day celebrations in Harrisburg. (Author's collection.)

Dave Kegris
For more than 30 years, Kegris has been the owner of the Jackson House, a lunch establishment in downtown Harrisburg made popular by its award-winning Philadelphia-style burgers. The photograph shows Kegris (left) with his sons Cory (cashier) and Chris (subs). (Author's collection.)

Pete Cangialosi
On August 1, 1974, Italian immigrant Giocchino "Jack" Cangialosi bought Naples Pizza in Steelton and offered it as a gift for his son Frank and daughter-in-law Rose. Even after Jack suffered a stroke in 1990 that left him barely able to communicate, the couple operated Naples Pizza seven days a week for 30 years. In 2008, their son Pete (above) assumed ownership of Naples. (Author's collection.)

James "Jim" Sharp and the Pennsylvania Farm Show

As the Pennsylvania Farm Show's management division administrator, Jim Sharp has become the face of the Commonwealth of Pennsylvania's signature agricultural event. A Jersey dairy farmer and graduate of Ohio State University, Sharp moved to Harrisburg in 1995 and began volunteering as superintendent at the Farm Show's All-American Dairy Show. In 2003, he was officially hired as the show manager of competitive agricultural events. The 1940s photograph below shows heavy traffic leaving the Pennsylvania Farm Show on Harrisburg's Maclay Street.

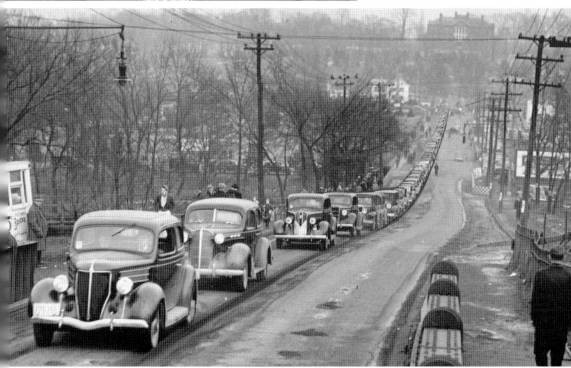

Edward J. Stackpole Sr., Edward J. Stackpole Jr., and Albert Stackpole

The Stackpole family arrived in Harrisburg about 1883 to work at the *Telegraph*. By 1901, the *Telegraph* was under the ownership of Edward J. Stackpole Sr. He was still with the *Telegraph* many years later when the Great War erupted. As his newspaper wrote for the general good of America's entrance into the Great War, Stackpole's two sons, Edward Jr. and Albert, were called to serve in 1917. Edward Jr. became a decorated captain in World War I, having received the Distinguished Service Cross for "extraordinary heroism in action," the Silver Star, and three Purple Hearts. In 1922, Captain Stackpole and his sister Kate dedicated the doughboy statue at Riverfront Park on Front Street near Old Midtown. Harrisburg's doughboy is one of about 160 "Spirit of the American Doughboy" statues that were sold to communities across the country in the 1920s. The Harrisburg doughboy rests on boulders brought from the Gettysburg Battlefield. In July 1922, after the great coal strike erupted in Washington and Fayette Counties, Gov. William Sproul ordered the National Guard in from Eastern Pennsylvania. Captain Stackpole Jr. led the troops who suppressed the violence. Stackpole Jr. had his footprint all over Harrisburg. He was a publisher and editor, launched a radio station called WHP AM, was a member of the Great Harrisburg Foundation, along with his father was one of the founders of the Harrisburg Zoological Garden near Wildwood, was the author of several books about the Civil War, and was an active participant in the City Beautification Movement of the 1920s. To Harrisburgers today, the Stackpole legacy is the family named company that has published works of more than 1,000 writers. In 1935, Edward Jr. and Albert opened Stackpole and Sons, later known as Stackpole Books, inside the Daily and Weekly Telegraph Building formerly located on Locust Street. After 80 years, Stackpole Books has published over 2,000 books related to military history, fishing, and crafts. Stackpole Book's best sellers include *Unsinkable*, *Street Without Joy*, autobiographies by Benny Goodman and Huey Long, and military textbooks including the *Army Officer's Guide*. The image shows Edward Stackpole Sr., center, in the early 1930s flanked by his sons Edward Jr. (left) and Albert (right), who are seeing him off on his cruise around the world. (Courtesy of M. David Detweiler.)

M. David Detweiler

For almost three decades, M. David Detweiler has been the most influential CEO of a book publishing company in Harrisburg. Born in Harrisburg on January 14, 1947, Detweiler attended city schools, the Harrisburg Academy, and Hotchkiss School in Connecticut before graduating with a bachelor's degree in English from Yale University in 1968. Book publishing has been in his family since before the Great War. Author of three novels and a book about the Battle of Gettysburg, Detweiler took over as CEO of the family's popular and enduring company Stackpole Books in 1986. Stackpole Books, which publishes books about hunting, fishing, crafts, and military history, has been in his family since 1935 when his grandfather Edward Stackpole Jr. (page 84) created Stackpole and Sons. When Detweiler took over the family business, the building was located on the corner of Cameron and Kelker Streets in the Old Telegraph Press Building. Today, Detweiler runs the business out of the Rossmoyne Business Park in Mechanicsburg. Pragmatic and adroit, with an Ivy League education, he has witnessed the publishing profession evolve rapidly during his tenure at Stackpole Books. The company continues to base its success on a close, even intimate, working relationship with authors, now using e-mail to correspond instantly with authors. Under his leadership, Stackpole Books sells mobile apps and e-books on Amazon, Nook, and Google, to name a few. (Courtesy of M. David Detweiler.)

Theophilus Fenn and the *Telegraph*
The *Telegraph* was founded in 1831 as a weekly to promote the Whig Party. Its founder, Theophilus Fenn, served as the newspaper's editor for more than 20 years. Fenn took public stances against slavery, causing a split between his newspaper and the Whig Party machine in Harrisburg. Throughout the Civil War and Reconstruction, Fenn's newspaper became the city's conduit for the Republican Party.

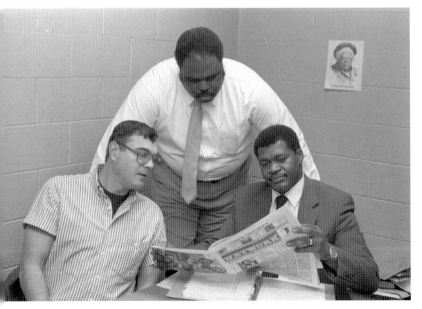

Nathaniel Gadsden
Named poet laureate of Harrisburg in 1998 by Mayor Stephen Reed (page 93), Nathaniel Gadsden (right) has affected the lives of nearly everyone in the city. Gadsden has published poetry for three decades. In 1977, he created the Nathaniel Gadsden's Writers Wordshop to help aspiring poets and writers. The image is one of the earliest showing Gadsden at work in his "wordshop" in 1991.

Rachel Nabors

Rachel Nabors was born in Harrisburg in 1985. She is an award-winning graphic novelist known for her archived comics at RacheltheGreat.com. On her 19th birthday, she became the first teenager in the country to self-publish her own graphic novel, *18 Revolutions* (2004). Once a resident of Bellevue Park, Nabors works as a nationally recognized Web designer. (Courtesy of Rachel Nabors.)

Carrie Wissler-Thomas

Originally from Lancaster County, award-winning artist Carrie Wissler-Thomas moved to Harrisburg in 1972. In 1986, she began a long tenure as president and CEO of the Art Association of Harrisburg. Today, scores of her paintings hang in homes, hotels, and castles around the world. She is famous for her oil paintings, notably her expressively realistic nudes, portraits, and costumed models. She has painted landscapes of the Susquehanna River and Scotland. (Courtesy of Carrie Wissler-Thomas.)

Gregory L. Sutliff

The photograph shows Greg Sutliff at Sutliff Chevrolet on Thirteenth and Paxton Streets in February 1989. Sutliff Chevrolet was founded in 1931. Sutliff entered the family business in 1943 as an assistant in the parts department. In 1968, he became dealer principal and on several occasions named General Motors' Dealer of the Year.

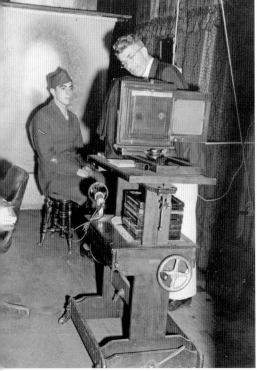

Samuel W. Kuhnert

Photographer Samuel Kuhnert (1890–1978) did most of his work from the sky. Born in Steelton, later a resident of North Third Street, Kuhnert first took aerial photographs of Harrisburg on June 7, 1920, from a Jenny biplane. Before his death, he had taken over 6,000 pictures of Pennsylvania. His work is preserved at the Pennsylvania State Archives.

Sean Simmers

Harrisburg's most renowned photographer of the new millennium is Sean Simmers. Simmers earned a bachelor's of fine art in photography from the University of Arts in Philadelphia and has worked for the *Patriot-News* since 2000. During his career, Simmers has been honored as the National Press Photographers Association's Photographer of the Year and has photographs published in the "America 24/7" project. Simmers is known for capturing some of the most memorable images of events in Harrisburg. (Photograph by Chris Knight, courtesy of Sean Simmers.)

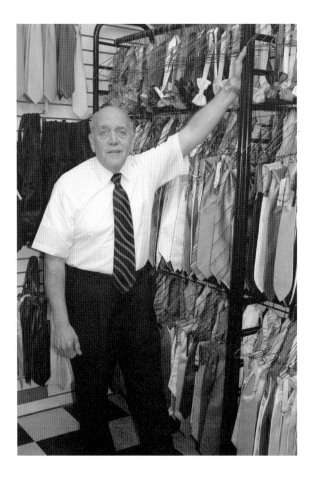

Greg Spiese

Since 1986, Greg Spiese has been the owner of Strictly Formals, a men's formalwear store that provides tuxedoes and three-piece suits for weddings and black-tie events. His shop has become the go-to place for prom-bound high school students in Harrisburg. With the hospitality of a bound-for-success owner and an altruistic hands-on presence, Spiese is among the most recognizable faces in Harrisburg; even if what he is most known for—fitting waists and collars—is on the retail side. In addition to Strictly Formals, for 30 years (1971–2001) Spiese provided lead vocals for The London Fog, a cover band that performed at venues throughout Central Pennsylvania. Starting in 1974, Spiese made a career out of men's formal attire as an employee of Glah Bros Tuxedo at Park City Mall in Lancaster County. After becoming manager of stores in Harrisburg, York, and Lancaster, Spiese was promoted to district manager in Philadelphia in 1981. He left the company in 1982 to work at Keebler Company from 1982 to 1985. He returned to men's formal wear in 1985 when a friend who managed Formal Affairs Tuxedos and Tailor Shop asked him to help launch a new store in York. Spiese was there only one year. In 1986, he attained ownership over Strictly Formals, located on Walnut Street in Harrisburg. Spiese knocked out a few walls and expanded the retail of his store, which was almost exclusively a catalogue provider. Within a year, he was hiring employees for the busy spring season. From the time he rented his first tuxedo in 1986 to 2013, Spiese has rented tuxedoes out to the likes of action-movie star Jean-Claude Van Damme; Karl Stover, the last surviving munchkin from *The Wizard of Oz*; and National Hockey League broadcaster Michael "Doc" Emrick. Spiese has been a generous donor to many local sports teams and foundations. Strictly Formals has been the official provider of formal wear for the Hershey Bears; has sponsored the Big 33 Classic's Buddy Program, Toys-For-Tots Foundation, Bishop McDevitt Ice Hockey team, and Little League baseball teams at the Boyer East League. (Author's collection.)

CHAPTER FIVE

Community Builders and Political Leaders

Harrisburg is not a city with history entrenched in great battles. Rather, its history is found in many unique individuals with reputations that made them known locally, nationally, and in some cases, internationally. When visitors come to Harrisburg, they do so to visit the Italian Renaissance-style architecture of Capitol Park, to see the attractions along the Susquehanna River, to enjoy the nightlife on Second Street, and to visit the city's various museums. In many respects, the people featured in this chapter constructed the landmarks in Harrisburg. Some like Mayor Stephen R. Reed and Calobe Jackson Jr. were lifers, born and raised in town. A few respectively sojourned in the city for a period of their lives. Others were carpetbaggers, choosing to build their lives in Harrisburg and call it home. The Harrisburg today is a product of their combined labors.

J. Horace McFarland

McFarland (1859–1948) was a leader in Harrisburg's City Beautification Movement. Working with city reformers Vance McCormick (page 17) and Mira Lloyd Dock (page 18), McFarland brought Riverfront Park, Wildwood Lake, over 20 miles of paved roads, and a water filtration plant to Harrisburg. McFarland oversaw the development of Harrisburg's most popular neighborhoods. The city line was extended in 1910 and Bellevue Park was incorporated. The illustrious Breeze Hill Mansion in Bellevue Park was McFarland's residence. He is seen in this image standing among his roses. McFarland was internationally known and was a pal of Theodore Roosevelt and conservationist John Muir. From 1904 to 1924, he was president of the American Civic Association, a role that allowed him to use his experiences in Harrisburg to advocate for the development of the national park system, a department to manage historic monuments, and roadside beautification.

Stephen R. Reed

In a lot of ways, Stephen Reed was Harrisburg. Yet, he is considered a lightning rod clouded with triumph and controversy. For nearly three decades, Stephen Reed was seen as the Democratic boss who put together a team, "The Reed Team," that saved the city by spearheading an economic revival that saw the transformation of City Island into a family playground and the emergence of scores of restaurants and museums. Yet his tenure ended amid allegations that he left the city on the brink of bankruptcy. He served 28 years as the mayor. In 2006, three years before he was voted out of office, Reed was a finalist for the World Mayor Award. The nomination joined him with city executives from Australia, Netherlands, Philippines, Madagascar, and Croatia. Although he finished third, Reed was recognized by the international organization for being a leading player in the creation of the Harrisburg University of Science and Technology. The honor was fitting for his loyalty to both the Democratic Party and the city of Harrisburg. Reed grew up in Shippensburg before his family moved to Harrisburg when he was 11. Reed, a Lutheran, attended Catholic schools in Harrisburg. He first enrolled at Holy Family School where he was baptized a Catholic. He then enrolled at Bishop McDevitt High School, class of 1967. When a senior at McDevitt, the *Patriot-News* recognized him as a prodigy debater. At a time when the voting age was 21, he founded the Teenage Democrats of Pennsylvania. When he was 25 years old in 1974, Reed ran against four-term incumbent George Gekas (page 20) for the state House of Representatives. Benefitting from the Republican backlash created by Pres. Richard Nixon and the Watergate scandal, Reed won. He served three terms as a state legislator. In 1981, at age 32, he was elected Harrisburg's mayor. In all, Reed served six consecutive terms as mayor. He was backed by both major parties in five of those elections. In 2000, the state legislature, backed by the Pennsylvania Department of Education, asked the Reed administration to take over the failing Harrisburg School District. It was the first time a Pennsylvania mayor had taken control of an entire school district.

Ron Marsico
Ron Marsico (born 1947), R-Lower Paxton, was first elected to the Pennsylvania House of Representatives in 1988. He has represented the 105th Legislative District of Lower Paxton, East Hanover, South Hanover, and West Hanover Townships with distinction. Marsico has written 21 bills that have become laws, including legislation that has dealt with Megan's Law, the death penalty, drug trafficking, and unwanted invasions of privacy. A 1965 graduate and former assistant football coach at Bishop McDevitt High School, Marsico became an inductee to the Capital Area Chapter Pennsylvania Sports Hall of Fame. Marsico is pictured welcoming Big 33 player Brian Lemelle, Bishop McDevitt's all-time leader in receptions (269) and receiving yards (4,529), to the capitol building on April 10, 2013. (Courtesy of Ron Marsico.)

Edward Marsico

A graduate of East Pennsboro High School, Edward Marsico earned degrees from Notre Dame (a bachelor's in government) and Dickinson School of Law before commencing a vast legal career that has made his name one of the most ubiquitous in Harrisburg. Marsico has served four terms as the Dauphin County district attorney, elected first in 1999. His trial experience includes more than 100 jury trials. He is an adjunct professor at Widener University School of Law and Harrisburg Area Community College. In its endorsement of Marsico's candidacy in 2011, the *Patriot-News* said, "Marsico has taken the lead in not only being tough on crime but more importantly, smart on crime." While in office, the number of cases in Dauphin County has increased from 5,000 to 6,000, but "the number of people in county jail has gone down thanks to the innovative programs that have reduced the prison population while still effectively dealing with crime and those who break the law." Marsico, a Republican, is applauded for being at the forefront of issues related to child abuse and child abduction. Marsico instituted crime-prevention programs such as education outreach in area schools. (Courtesy of Ed Marsico.)

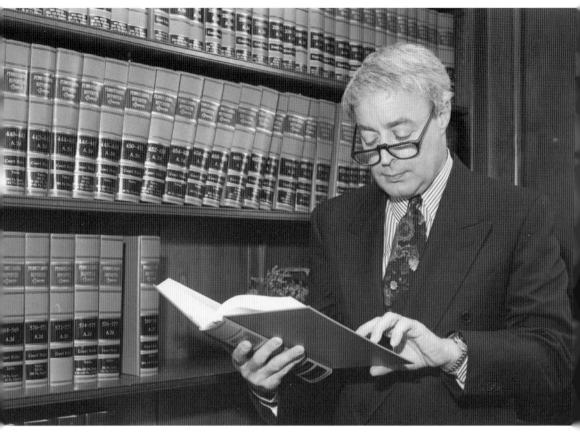

Corky Goldstein
Corky Goldstein's first contribution to Harrisburg was Central Pennsylvania Legal Services, an economic service for low-income citizens. His legal service corporation was named one of the top 10 legal service projects in the country. Arguably, Goldstein's legal services were proactive while dealing with race relations in Harrisburg, which prevented the outbreak of race riots in the late 1960s. In his lifetime, he has hosted two weekly radio shows called *Ask the Lawyer* and *Corky's Court*. Goldstein has served on the boards of the Special Olympics, the NAACP, State Medical Association, and Jewish Community Center. Corky has been the city-solicitor, vice president of the Harrisburg City Council, and member of the Harrisburg School Board. He has received several awards, including the Man of the Year American Bar Association public service award.

Robert Welsh

In 1995, Bob Welsh and a friend were walking down Division Street one day when they saw two teenagers on the other side of the street. Bob's friend took out a $20 bill and ripped it in half, saying to the kids that he would give them the other half if they were able to identify 16 and 7/8 inches on a tape measure that he was carrying. The youths could not do it. Welsh's friend said, "That is what is happening to our kids." The encounter changed Welsh's perspective about his own life. At the time, Welsh was a voting member of the Grammy Academy, songwriter, bass player, and owner of the Green Room Studios located on Front Street. It took him a few years, but Welsh figured out how to launch a nonprofit music program that offered educational services to youngsters in Harrisburg. In 1997, Welsh became a board member of Metro Arts of the Capital Region (present-day Jump Street, Inc.), which aimed to promote healthy lifestyles though artistic expressions. It was in this capacity that he created the Gift of Music program that is responsible for providing musical instruments to more than 4,000 kids who could not afford one of their own. Welsh set up stationary locations throughout the city where the public could donate instruments. Jeff Abercrombie, the bassist of the Grammy-nominated band *Fuel*, donated the first instrument to Welsh's program. Now, Philadelphia, York, Lancaster, and Allentown each have their own Gift of Music program modeled after the work that Welsh began brainstorming on that poignant day in 1995. Welsh is a well-accomplished artist who has written songs for Dolly Parton, Jeffrey Gaines, and more, as well as having music credits for many network television shows, including the NBC Today Show. He has written more than 700 songs, cut and released 50 titles, and published 50 additional songs. Also, Welsh's recording studio the Green Room is responsible for recording live radio productions for Fuel, Marcy Playground, and Brother Cain. His esteemed musical career aside, Welsh's work as executive director of Jump Street, Inc. is his defining accomplishment. Today, Jump Street provides art education opportunities for Harrisburg's citizens of all ages. In 2009, Welsh received the Governor's Keystone Award for Innovation for his work as executive director of Jump Street. (Courtesy of Bob Welsh.)

Jeannine Turgeon

Honorable Jeannine Turgeon, whose father was a soil engineer for the Department of Highways and whose mother was a school nurse, was no ordinary girl growing up in Harrisburg during tumultuous days of racial unrest and antiwar protesting. Born March 19, 1953, Turgeon attended Central Dauphin East High School where she became interested in the Democratic Party, became a student leader responsible for forming the Teenage Democrat Club and Environmental Club, and by her junior year was working on her first campaign. Turgeon's future is dignified, with internships working for Genevieve Blatt (page 22) and C. Delores Tucker (page 23). Turgeon earned a law degree from the University of Pittsburgh Law in 1977, began practicing at Nauman, Smith, Shissler, and Hall in 1979, and in 1991 became partner in her own firm, Campbell, Spitzer, Davis, and Turgeon, later Davis and Turgeon. In November 1991, she was elected as the first woman judge of the Court of Common Pleas of Dauphin County. Since her initial election, Turgeon has become one of the most renowned judges to serve in Pennsylvania. In 2009, she was awarded the Coretta Scott King Women for Diversity Award for her remarkable record of service to Dauphin County. Turgeon has chaired a subcommittee examining the establishment of a family court, rewritten the instructions for the Pennsylvania Civil Jury that included allowing jurors to take notes and receive written copies of certain jury instructions prior to deliberations, chaired the Pennsylvania Sentencing Commission responsible for creating statewide resentencing guidelines, has taught at Widener University Law School, and has helped write *Bellevue Park's First 100 Years*.

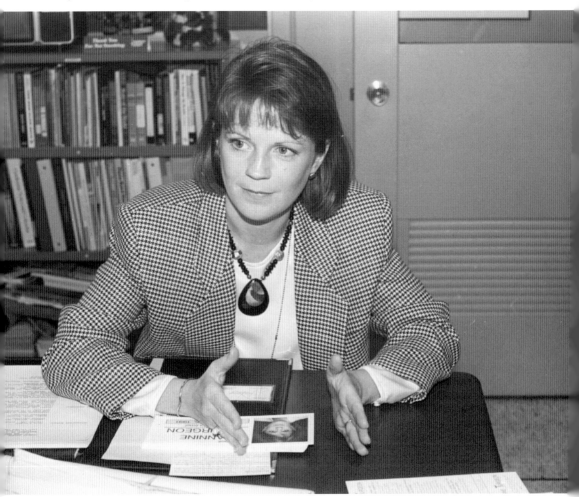

Calobe Jackson Jr.

Calobe Jackson Jr., born April 20, 1930, grew up in the "Harlem of Harrisburg," a segregated community on the west side of Aberdeen Street, near the present-day Old City Hall Building. In 1921, Calobe's father opened a barbershop on Aberdeen Street, and later relocated to North Sixth Street. In 1946, the Jackson family opened Jack's Hotel. The family barbershop and hotel operated as the nucleus for African Americans from Harrisburg and elsewhere. Much of Calobe's childhood was spent observing many illustrious visitors who stayed at his family's hotel, including Nat King Cole, Sugar Chile Robinson, Little Walter, W.C. Handy, Olin Harris, Rev. Belgium Baxter, and others. Calobe attended integrated public schools, including Boas Elementary School, Camp Curtin Junior High, and William Penn High School. He was a sprinter on a record-setting track and field team at William Penn. After high school, Jackson was awarded a scholarship and attended Lincoln University in Chester County during the time that Horace Mann Bond, the father of former NAACP president Julian Bond, served as the institution's president. In March 1951, Calobe was drafted to serve in the Korea War. Calobe became a surveyor in one of the US Army's last segregated units, the 94th Engineer Battalion. After he was discharged in 1953, Jackson worked as a clerk and supervisor for the United States Postal Service for 35 years. The position made Calobe the third African American supervisor at USPS. He later became general foreman and tour superintendent before retiring in 1990. Jackson is known today as the guru of local history, namely topics surrounding the Negro Baseball Leagues and general African American history. The picture shows Calobe in November 2010 portraying legendary abolitionist-journalist Thomas Morris Chester (page 20). Calobe has also served three terms on the Harrisburg School Board, elected in 1993 and 1996, and appointed by the city's mayor to the board in 2001. (Courtesy of Calobe Jackson Jr.)

Harvey "Haps" Boyer

Pictured here on June 12, 1986 is Harvey "Haps" Boyer. For more than 35 years, Boyer, a graduate of John Harris High School, served as president of the Midget Baseball Association of Harrisburg. A resolution passed by the board of the Boyer East Baseball League in 1989 named the clubhouse at Twenty-fifth Street and Rudy Road for "Haps" Boyer.

John F. Cherry

John Cherry, shown here in 1990, is the hardened district judge who became popular in Harrisburg in 1993 when he was appointed district attorney. One year later, Cherry was elected to the same position, where he served Dauphin County until 1999. In 1999, Cherry was elected to the bench on the Dauphin County Court of Common Pleas.

Philip Berrigan and the "Harrisburg Seven"

Berrigan was a notorious antiwar protester during the Vietnam War era, and the most radical pacifist for a time in Harrisburg. In April 1972, Berrigan, formerly a Catholic priest, and the "Harrisburg Seven" were acquitted by a 10 to 2 hung jury of 23 counts including a plan to kidnap President Nixon's aid Henry Kissinger, conspiracy to blow up underground heating tunnels in federal buildings in Washington, DC, and conspiring to destroy draft records. The image shows Berrigan on a hunger strike to protest the draft.

FATHER DAN AND JERRY BERRIGAN ARE FASTING UNTIL JUDGE HERMAN STOPS DELAYING A DECISION ON FATHER PHIL.

YOU CANNOT IMPRISON THE WORD OF THE LORD

Linda Thompson

Aside from the time she attended Howard University and worked as an intern at the United States Department of Justice, Linda Thompson has spent her entire life serving the needs of Harrisburg. A graduate of Harrisburg High School, class of 1979, Thompson was first elected to the city council in 2002, and again in 2005. From 2004 to 2006, she was the council's vice president. She was the city council's president from 2007 to 2009. On January 4, 2010, Thompson was sworn in as Harrisburg's 33rd mayor. Her landmark election over 28-year mayor Stephen Reed made her Harrisburg's first African American and female mayor. (Courtesy of Sean Simmers.)

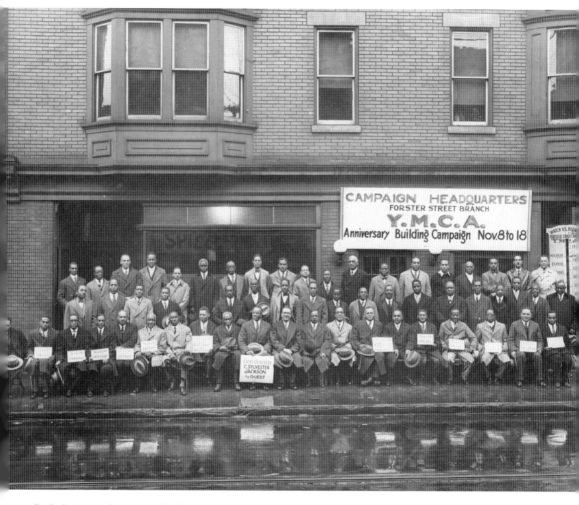

C. Sylvester Jackson, J. P. Scott, Dr. Charles Crampton, Lawrence Daniel Williams and the leaders in the division to raise funds for the Forster Street Colored Men's YMCA, November 1929

Shown here are members of the Forster Street Colored Men's YMCA in November 1929. The Forster Street YMCA was popular nationally. From left to right are the following: (first row) Pat Jefferson, Edward Fox, F.D. Gholston, J.W. Fitzhugh, P.C. Moore, R.A. Posey, B.B. Jeffers, W.J. Hooper, A.E. Barbour, C. Sylvester Jackson, R.B. DeFrantz (director), Dr. Charles H. Crampton, William H. Bond, Dr. A.L. Marshall, J.P. Clifford, G.S. Winters, R.R. Cooper, George Powell, William Spotwood, and L.E. Robinson; (second row) George Dews, Frank Jackson, Walter Harris, George Chase, W.P. Boynton, John Baker, Edward Taylor, Aaron Green, James Armstrong, Elam Banks, Henry Robinson, Nelson Brown, S.W. Parsons, James Ross, Albert Jones, Harry Green, Robert Waters, and Benjamin Gray; (third row) Dave Williams, Charles Williams, William Glover, the Reverend Jenkins, Allan Frye, Vernon James, W.T. Shields, Dr. Reynolds, T. Nelson Potter, Charles Thomas, Sylvester Ellison, J.P. Scott, Edward Whiten, Ross Johnson, Claude Dent, W.F. King, Delaney Robinson, C.E. Sampson, and Arthur Fields.

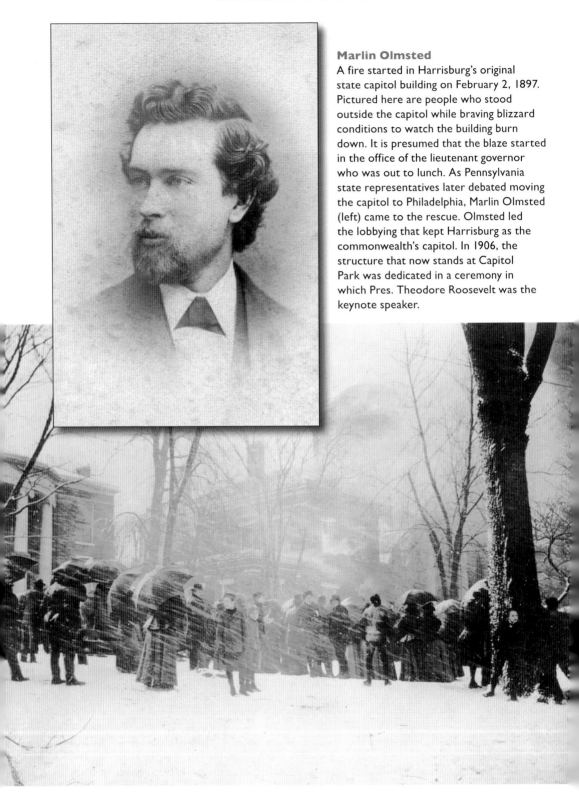

Marlin Olmsted

A fire started in Harrisburg's original state capitol building on February 2, 1897. Pictured here are people who stood outside the capitol while braving blizzard conditions to watch the building burn down. It is presumed that the blaze started in the office of the lieutenant governor who was out to lunch. As Pennsylvania state representatives later debated moving the capitol to Philadelphia, Marlin Olmsted (left) came to the rescue. Olmsted led the lobbying that kept Harrisburg as the commonwealth's capitol. In 1906, the structure that now stands at Capitol Park was dedicated in a ceremony in which Pres. Theodore Roosevelt was the keynote speaker.

Candace Gingrich-Jones

Candace Gingrich-Jones (born 1966), a 1984 graduate of Central Dauphin East High School, currently works as manager of the Human Rights Campaign's National Coming Out Project. Candace is the half-sister of former house speaker Newt Gingrich, also born in Harrisburg. She and Newt did not grow up together, but they share the same mother. Candace lived in many places in the country and Panama before settling back in Harrisburg. Her political activism began in 1995 when she became the spokesperson for the Human Rights Campaign's National Coming Out Day. She has made appearances on *Good Morning America*, *Larry King Live*, and *Countdown with Keith Olbermann*. Gingrich-Jones writes a blog for *The Huffington Post* and has appeared on MSNBC's *Rachel Maddow Show*. Her popularity has exploded in recent years with appearances on trendy shows *Ellen* and *Friends*. In April 2011, Gingrich-Jones received the American Humanist Association's Humanist Pride Award for her work combating intolerance, and in particular to her support of Constance McMillan, a high school senior from Tupelo, Mississippi, who was denied from her prom because of her sexuality. Gingrich-Jones helped develop the HRC's Welcoming Schools Guide that advises teenagers, administrators, educators, and parents about how to be proactive against bullying. She is a vocal advocate for the "Second Chance Prom" movement that helps provide thousands of people across the country that were bullied in high school because of their sexual orientation with an opportunity to have a prom experience. (Courtesy of Candace Gingrich-Jones.)

Graham Hetrick

Pictured above with his loyal companion Sherlock, Graham Hetrick grew up in Harrisburg above his family's funeral home. He served in the United States Army during the 1960s and was assigned to the military police and later the 52nd Criminal Investigation Division in the southern half of Germany. Hetrick return to Harrisburg and worked as the owner and director of Hetrick Funeral Home. He was elected Dauphin County Coroner in 1990. Below is Hetrick in his laboratory. In 2013, A&E signed Graham Hetrick to star in a reality docudrama. Famous locally for his signature bow-ties, his eccentric personality is front and center in *Graham of Evidence*, a reality TV show that educates viewers about the science of uncovering how a person dies. (Author's collection.)

CHAPTER SIX

Educators and Religious Leaders

At the heart of every community are its schools and churches. The citizens of Harrisburg have been privileged with selfless schoolteachers like John P. Scott and Carole Bush. Both educators represented different eras of education, yet they are proof of the quality teachers that spent their lives teaching at Harrisburg's public and private schools. Before relocating in 2013, the picturesque Bishop McDevitt High School building sat at the foot of Reservoir Park along Market Street for almost a century. Just two blocks away is Harrisburg High School. College students at Penn State University's Harrisburg campus boast about Simon Bronner, the country's preeminent folklorist. Meanwhile, Lenwood Sloan has invested many years preserving the cultural heritage of Harrisburg at numerous schools in the city.

While schools teach the history and culture of Harrisburg, the various communities would be lost was it not for the religious leaders who minister to the masses. The largest religion represented in Harrisburg is Catholicism. Also represented are Lutheran, Methodist, Presbyterian, Jewish, Islamic, and Baptist belief systems.

This chapter is a tribute to these custodians of Harrisburg's cultural heritage.

Nancy Mendes
Mendes is known for her original artwork of topics related to Harrisburg. In 2010, she worked as exhibits designer for the Harrisburg History Center, a local museum designed to provide visitors with the history of Harrisburg. In addition to working as an adjunct professor at Penn State-Harrisburg University, she collaborated with others on heritage projects for the city, including the Sesquicentennial and the Living Legacy Project. (Author's collection.)

Bishop Philip R. McDevitt
In 1916, Monsignor Philip McDevitt was relocated from Philadelphia, where he was the superintendent of Catholic schools, to Harrisburg to serve as bishop of the Catholic diocese. After 19 years in Harrisburg, he oversaw the opening of 10 parishes and 12 Catholic schools. In 1957, Harrisburg Catholic High School was renamed Bishop McDevitt High School in his honor. (Courtesy of La Salle College High School.)

Bishop Nathan Baxter
The Washington National Cathedral's
10th Bishop was Nathan Baxter. Born
November 16, 1948, Baxter grew up
in Harrisburg, was a multisport athlete
at William Penn High School, and
decorated veteran of Vietnam. He was
consecrated bishop of the Episcopal
Diocese of Central Pennsylvania on
October 22, 2006. The seat of Baxter's
bishopric is St. Stephen's Episcopal
Cathedral in Downtown Harrisburg.
(Courtesy of Calobe Jackson Jr.)

Rabbi Eric Cytryn
Rabbi Cytryn arrived in
Harrisburg by means of New
Orleans and St. Louis in 2003.
As the Rabbi of Beth El Temple,
Cytryn has helped to create
innovative programs in Family
Education and Spirituality. Most
noteworthy, his food bank supplies
Jewish Harrisburgers with Kosher
food and the non-observant with
general food. (Courtesy of Sean
Simmers.)

109

John Howard Wert
J. Howard Wert (1841–1920) was an abolitionist, graduate of Gettysburg College, Union scout, and later lieutenant in Company G, 209th Pennsylvania Volunteers. In 1874, he arrived in Harrisburg to be a teacher at the Boys' High School. In 1879, Wert became principal and oversaw the graduation of the city's first African American students. He served as principal of Harrisburg High School from 1893 to 1894.

William H. Egle
Born in Harrisburg, William Egle (1830–1901) wrote the 19th century version of *Legendary Locals of Harrisburg*. Egle's book was called *History of the Counties of Dauphin and Lebanon* (1883). Before his role as city historian, Egle had attained a medical degree from the University of Pennsylvania. During the Civil War, he worked as a surgeon for the 47th Pennsylvania Regiment.

Michael Barton

Professor and author Michael Barton was born in Nebraska and earned degrees from the University of Nebraska and University of Pennsylvania. While living in Philadelphia, Barton was hired to teach at Penn State Harrisburg University in 1972. He commuted to Harrisburg until he and his wife bought a house in Shipoke in 1980. Arriving just years before the city's economic revival began under Mayor Stephen Reed (page 93), Barton has indisputably been part of the emergence of contemporary Harrisburg. He became a prominent contributor to the historic preservation of the city, where he has served on the board of directors for the Dauphin County Historical Society, Historic Harrisburg Association, Shipoke Neighborhood Association, and City of Harrisburg Sesquicentennial Celebration to name a few. For 40 faithful and industrious years, Barton has worked at Penn State's branch campus in Harrisburg. In an unparalleled way, Professor Barton has offered his students a practical experience by including them in his local history projects. His pupils have been offered opportunities related to archival work, transcription, publishing, and presentation. Of note, Barton has presided over projects related to Harrisburg's Old Eighth Ward, the McCormick Family Papers, the Charles Rawn Journals, and the Paul Beer (page 73) *Patriot-News* columns. To date, 155 undergraduate and graduate students have become authors, editors, and coeditors because of their experience working with Barton. His service to Penn State, his students, and the city of Harrisburg has not gone unnoticed. In 2009, Penn State-Harrisburg honored him with the Faculty Service Award, and Dr. Barton was named Top Harrisburg History Writer by the *Patriot-News*. Barton has written three books about the Civil War and six books about Harrisburg. He has spoken about various American cultural topics at conferences in Scotland, Finland, Ireland, Australia, the Republic of Congo, and the Republic of Georgia. Barton often takes undergraduate and graduate students abroad with him to American studies seminars. He currently serves as director of the Center for Pennsylvania Culture Studies at Penn State Harrisburg. (Courtesy of Michael Barton.)

Milton Lowenthal
Milton Lowenthal was an activist involved in antinuclear movements in Harrisburg, specifically those related to Three Mile Island and the bombings of Hiroshima and Nagasaki. Lowenthal sponsored the artwork of Japanese artist Kazuaki Kita—known locally for his yearly "After Hiroshima" calendars. Due to Lowenthal's advocacy, Harrisburg's Mayor Stephen Reed (page 93) declared the week of August 6 to August 12, 1989 "Harrisburg-Hiroshima-Nagasaki Remembrance Week."

Benjamin F. Turner
In 1974, the Harrisburg School District hired its first African American superintendent. The move was groundbreaking for a city that dealt with an ugly series of race riots in 1969, a great flood that crippled the city in 1972, and white flight that left the enrollment in Harrisburg schools at 54 percent African American.

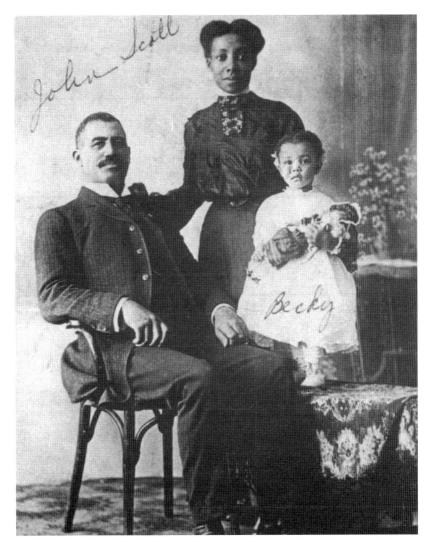

John P. Scott

John Paul Scott (1859–1931) and his friend William H. Marshall were the first African American students at the old Harrisburg High School, located near State Street. Scott graduated as salutatorian in 1883. His commencement speech was titled "Stand for Yourself." One teacher called Scott's admittance test results the "most brilliant [scores] ever recorded in Harrisburg of grammar school pupils applying for admissions to the High School." Immediately after high school, Scott taught at the Calder School and Lincoln School (later William Howard Day School), two segregated schools in Harrisburg. For 47 years, he held various academic jobs from principal to night school teacher. The Scott Elementary School on Derry Street is named after him. During his lifetime in Harrisburg, Scott was a protégé of Harrisburg's first African American school board president William Howard Day (page 12), who mentored Scott in positions within the Wesley Union A.M.E. Zion Church and leadership duties within the Brotherly Love Lodge, Grand United Order of Odd Fellows, and Prince Hall Grand Masonic Lodge of Pennsylvania. In 1890, Scott was elected Eighth Ward Assessor. In 1892, Scott became the treasurer of Lincoln Cemetery, a segregated cemetery in Penbrook. Scott married Estella Harris of Bedford around 1900. They kept a home valued at $1,400 until his death. On the day of his funeral, all city schools canceled classes in his honor. He is buried at William Howard Day Cemetery in Steelton, Pennsylvania.

Simon Bronner
Simon Bronner, an award-winning scholar at Penn State-Harrisburg University, is one of the most distinguished professors in the state of Pennsylvania and folklorists in the United States. An author of a myriad of books and articles, Bronner is the recipient of the Jordan Award from Penn State University for teaching and the Mary Turpie Prize from the American Studies Association for program development. (Courtesy of Simon Bronner.)

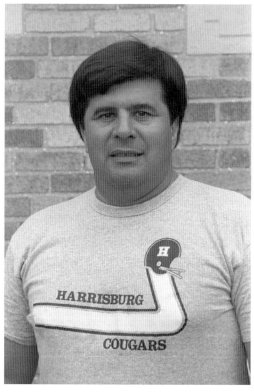

Jim Deibler
Originally an employee at Harrisburg High School, Jim Deibler became a legend at Steel High as the school's head football coach and assistant principal during the 1980s. For four seasons, 1981–1984, Deibler led the Rollers to a school record 19-game win streak and the 1983 Triple-A District 3 championship. Deibler suffered from severe degenerative arthritis and circulation problems that forced him to retire after 27 years as the school's principal in 1999.

Carole Bush

It is fine to help young creative minds, but first you have to know what it takes. Obviously, Carole Bush proved that she knew. Over the course of a teaching career that spanned more than 35 years, Bush became the face of Bishop McDevitt High School's English department. Nearly 30 of those years were spent at McDevitt, where she taught a variety of courses, including Humanities, British Literature, and Shakespeare and Modern Drama. Bush served as the chair of the English department, National Honor Society, and Christian Service Club. Also, she developed and taught two summer writing courses. Her philosophy was intense: to provide each student with examples in literature that presents both the best and the worst characteristics of a given society. Bush focused on pushing her students to create clever characters and plot twists. She grew up across the street from the illustrious J. Horace McFarland Mansion (page 92) in Bellevue Park. As a teenager, she volunteered as a candy striper at Holy Spirit Hospital. As a teacher, she voluntarily took students to England, France, and Italy where, as Bush explains, McDevitt's "English and history courses came to life before our eyes." With help from faculty and parents, in 2001, Bush guided students through Europe's most historic landmarks, including a tour of Shakespeare's Globe Theatre, a pilgrimage to Canterbury Cathedral, mass at Westminster Cathedral in London and the Cathedral of Notre Dame in Paris, tours of Mont St. Michel in Normandy and the Hall of Mirrors at Versailles. Again in 2006, Bush and her colleagues took students to Italy, where they visited Rome, Venice, Florence, Pisa, Verona, and Padua. Her trips to Europe were one of her gifts to her students; her impact on their lives was an even more enduring one. The image shows Carole Bush at the shrine of Saint Francis of Assisi in Italy. (Courtesy of Carole Bush.)

Lenwood Sloan

In 2012, Susquehanna Township School District, in cooperation with Jump Street, Inc. hired master artist Lenwood Sloan to supervise the creation of the School of the Arts. The program offers three tracts: Theater Arts, Visual and Fine Arts, and Production Lab. Few people in Harrisburg measure up to Sloan's ability to offered students such a range of unforgettable art programs. In 1984, Sloan was hired by Rouse Company to create "Art in the Market Place" programs, a task demanding he bring atmospheric music, murals, arts and crafts, and special events to various tourist centers. His work for Rouse Co. can be seen at the Baltimore Harbor, South Street Seaport in Manhattan, Seattle Mall, St. Louis Union Station, and New Orleans River Walk. Sloan assisted in the production of four nationally televised documentaries, *Treme-Untold Story*, Emmy Award–winning *Ethnic Notions, Stephen Foster*, the internationally acclaimed *Re-Imagining Ireland*, and the Emmy Award–winning *Dance Black America*. Discovered in a nationwide search by the Rendell administration in 2005, Sloan was hired to serve as director of the Pennsylvania Department of Cultural and Heritage Tourism. Sloan has since made Harrisburg his home. With late-Joseph Kelly, Sloan also conceived and directed the Pennsylvania Humanities Council's Live and Learn Cultural and Multicultural Literacy Project. The initiative introduced over 30 new works to book clubs and cultural communities through shared readings, dialogues, and PHC events. He won two awards while he was PCHT's director—the 2011 Pennsylvania Historical Society's Innovation Award and Pennsylvania System of Higher Education's Martin Luther King Humanitarian Award. As an employee of the Commonwealth of Pennsylvania, Sloan created the Pennsylvania Past Players/100 Voices, a project that trained college students to portray one of 100 soldiers of the US Colored Troops. Sloan's work for the Susquehanna School of the Arts has won him the 2012 Jump Street, Inc. Excellence in Arts Award. The photograph is by Eric Baiano. (Courtesy of Lenwood Sloan.)

CHAPTER SEVEN

Heroes and Veterans

The Greeks believed that heroes were created when a mythical god came to Earth and mated with a human. Their offspring became a hero, part heavenly and part earthly. Yet today, as a culture, many people have struggled to define a hero. People have become disillusioned about valor and heroism. Some professional athletes have admitted to taking performance-enhancing drugs. Public officials have accepted bribes. Even celebrities, religious leaders, and coaches have disappointed supporters. One needs to acknowledge that leaders are flawed, will sometimes disappoint, and might also be judged by reckless private behavior over public accomplishments.

Ordinary people, those who usually remain nameless and faceless, and who have fallen through the endless cracks of the past, have really been the builders of communities. Presumably, local and military heroes are people who, over the course of history, have made sacrifices. In large and small ways, these people have built Harrisburg.

Ann Durr Lyon

At age 60, Ann Durr Lyon (1927–2013) was diagnosed with breast cancer. It was an era when people refused to talk about the disease. Chemotherapy was not an option, leaving a lumpectomy combined with radiation treatments as Ann's only medical option. She challenged the cultural norm by talking publicly about her battle against breast cancer. She contended, having breast cancer "gives you permission" to do what you want to do. In Harrisburg, she started a breast cancer support group. Her courage was a consequence of growing up in a politically active family. Originally from Birmingham, Alabama, her father was Clifford Durr, the lawyer who represented Rosa Parks in her challenge of the Jim Crow law that kept public busing segregated in Montgomery. Her mother was Virginia Durr, a friend of Parks's and Eleanor Roosevelt's who made a name for herself by running for the US Senate from the state of Virginia in 1948. Ann (left) and Virginia are pictured here at Ann's Camp Hill home celebrating the publication of Virginia's autobiography *Outside the Magic Circle* in August 1992. Ann's fascination with her parents' experience in the Civil Rights Movement gave her the strength to beat breast cancer and give strength to others in her support group. Ann ended up teaching sociology and civil rights courses at Harrisburg Area Community College. She created the Human Service Program at HACC. The program helped her attain Emeritus status. Ann was also instrumental in creating several other initiatives in Harrisburg. She cofounded the Temple University Graduate Program in Social Work. The NAACP and other civil rights groups honored Ann for establishing the Harrisburg Civil Rights Oral History Project. She worked with the National Council of Jewish Women and the League of Women Voters. She passed away at her home on February 7, 2013. She was 85 years old. Two months after she died, HACC created the Ann Durr Lyon Award, a $1,000 scholarship given to a student in the human services program or social sciences who has demonstrates high academic achievement and has made significant contributions to the human services field.

Gen. Joseph Knipe

Joseph Knipe was an aide-de-camp to Brig. Gen. Edward Williams and one of the decision makers that identified Camp Curtain in Harrisburg as the training center for Pennsylvania's volunteers after the Confederate bombing of Fort Sumter. In September 1861, Knipe was commissioned as a colonel and given responsibility to raise the 46th Pennsylvania Volunteers.

Gen. Horace Porter

Horace Porter lived in Harrisburg after his father David Porter was elected governor in 1838. He was serving as an instructor in artillery at West Point when shots were fired on Fort Sumter. At the Battle of Chickamauga in 1863, Porter rallied volunteers to hold the ground under heavy fire to help hundreds of enslaved persons escape. Porter received the Congressional Medal of Honor for his heroics.

119

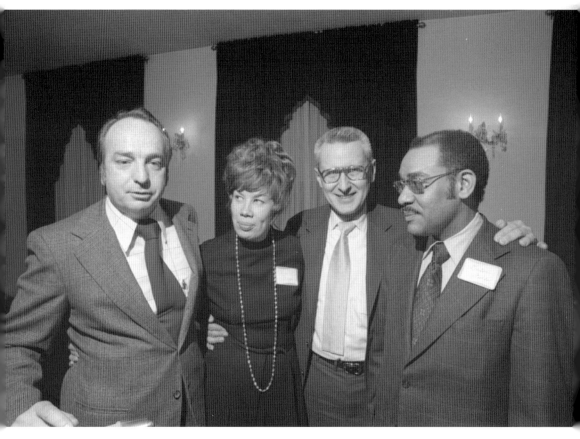

Frank Haas

Haas, born in 1926, saw combat in the Pacific Theater during the final year of World War II. A graduate of William Penn High School, Bucknell University, and Pennsylvania Law School, Haas worked as managing partner in the McNees, Wallace & Nurick law firm. He also worked as Harrisburg School Board president, city solicitor, and president of the Dauphin County Bar Association. In 1997, the Capital Region Economic Development Corporation named Haas Catalyst of the Year for his efforts to reform local government and his help organizing the Harrisburg Area Transit Authority. He is pictured (third from the left) with friends at the Public Administrator Society meeting at Schindler's Restaurant.

Michael Markowski

Born in Harrisburg, Mike Markowski is an award-winning aerospace engineer, pilot, and Experimental Aircraft Association Hall of Famer. While working on the Space Shuttle for NASA in 1971, Markowski left his mark in the aviation field when he built and flew his first hang glider in Massachusetts. Almost instantly, he began publishing *Skysurfer* magazine and opened two hang gliding manufacturing companies. He returned to Harrisburg in 1975 and has since authored eight aviation books and started a publishing company Aeronautical Publishers and Possibility Press. In 2009, Markowski received the Pennsylvania Aviation and Aerospace Achievement Award, which is the Commonwealth of Pennsylvania's highest aviation honor. The image shows Markowski (right) in May 1985 with Brad Miller of Hummelstown Emergency Medical and Rescue Service after he invented a lifesaving instrument known as VITAL.

Tom Murray

As a member of Pennsylvania Task Force One, Tom Murray was part of a unit that responded to the terrorist attack on the World Trade Center on September 11, 2001, and Hurricane Katrina in August 2005. For 30 years, Murray worked at the Harrisburg Fire Department. In June 2007, he was promoted to deputy chief of the Harrisburg Bureau of Fire. Murray is pictured above at the St. Patrick's Day Parade in 2006. He is also shown in 1985 fighting a fatal fire in Shippensburg. The photograph below appeared in *Firehouse Magazine* and newspapers worldwide. (Courtesy of Chris Shatzer and Chambersburg *Public Opinion* newspaper and Tom Murray.)

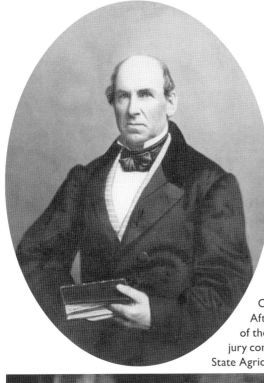

The Rutherford Family

The owners of vast farmland in Swatara, the Rutherford family had established themselves as renowned abolitionists. The most famous Rutherfords were Dr. William Wilson Rutherford (pictured first) and Capt. John Parke Rutherford (pictured second, left with William Kelker). William (1805–1873) was one of the founding fathers of the Harrisburg Anti-Slavery Society. He also lived in a house on South Front Street, which doubled as a doctor's office. John Parke (1802–1871) served as Dauphin County quartermaster during the Civil War. He was stationed at Harper's Ferry, Camp Douglas, and at Charleston, South Carolina. After the war, John Parke worked as superintendent of the Wiconisco Canal, auditor of Dauphin County, a jury commissioner, and vice president of the Pennsylvania State Agricultural Society.

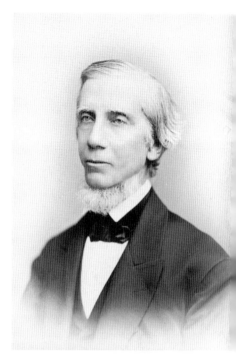

Rudolph Kelker

Kelker (1820–1906) is known most as owner of a hardware story and well-known abolitionist. From 1854 to 1891, he served as trustee, secretary, and treasurer of the Harrisburg Academy. For many years, Kelker was one of the directors of the poor for Dauphin County, and trustee of the Pennsylvania Lunatic Asylum at Harrisburg. In 1873, he became the founder of the Harrisburg Hospital.

Donald H. Konkle

In 1982, Donald Konkle was appointed chief of the Harrisburg Bureau of Fire. Konkle had first joined the fire department in 1974. He also worked as president of the Dauphin County Fire Chiefs Association, was the city's emergency management coordinator, and served as sponsoring agency chief for Pennsylvania Task Force One and Task Force Two. He is pictured at the Fire Training School at HACC in 1989.

Lee Swope

After graduating from William Penn High School and Duke University, Lee Swope (1921–2003) served 43 months as a lieutenant in the US Navy during World War II. He worked as a Japanese language interpreter for the Naval Intelligence Division. Judge Swope was a member of the Dauphin County Supreme and Superior Court Bars. He also was involved in the Dauphin County Democratic Party.

Sebastian D. Natale

Pictured here voting in May 1983 at the Bellevue Park Community Building, Sebastian "Andy" Natale (1924–2002) was an Italian immigrant, star football player at Harrisburg Catholic High School (present-day Bishop McDevitt), and judge on the Dauphin County Court of Common Pleas from 1986 to 1994. Natale was a decorated soldier in World War II, having received the Asiatic Pacific Campaign Medal with eight Bronze Stars.

INDEX

INDEX

MADE IN THE